**Design**Originals

# NOTEBOOK DOODLES
# COLOR SWIRL
## JeSS ♥ VOLiNSKi

This book
was colored by:

Design Originals
an Imprint of Fox Chapel Publishing
www.d-originals.com

# Be YOURSELF to be creative

The thing I love most about art—making it myself or enjoying others' creations—is that **art allows you to be yourself by expressing yourself.** Whatever you love, whatever is important to you, whatever makes you who you are should come out in your art. By making art that matters to you, you're starting a conversation with everyone who sees it. You're saying, "Hey! This matters to me. What do **you** think about it?"

You might be wondering, how exactly do I express myself with art? That's where **The Elements of Art** come in. You might remember these from art class. Just like writers use words to tell a story, artists use these visual elements to express themselves and start their art conversation. All visual art—whether it is a painting in a museum, storyboards for a movie, a pattern on a bag, or a coloring book page—uses some combination of these seven basic building blocks of art. Not all art has to include all seven elements, but most art will include a few.

## The Elements of Art

A **line** is formed as the connected distance between two points. Lines can be thick or thin, straight or curved.

**SPACE** ▢○ ●

**Space** refers to the areas in a piece of art that are around or within different parts of the art. There are two kinds of space: negative (space around areas), and positive (space within areas).

A **shape** is a defined area of space—a circle, square, blob, or a flower petal are all shapes.

**TEXTURE**

**Texture** refers to the way the art physically feels when touched, or how an artist visually makes the art **look** like it would feel. Shading with pencils is an example of this type of visual texture.

**FORM** ● ▣

Something has **form** if it has volume (or creates the illusion of volume). A three-dimensional sculpture has form. A two-dimensional drawing with shading that makes it appear three-dimensional can also have form.

**COLOR**

**Color** is created when light hits an object and is reflected to our eyes. A color can be described with three properties: hue (the color's name, such as "red"), value (how light or dark the color is, also called a tint or shade of the color), and intensity (how vivid or dull the color is).

**Value** refers to the relationship between light areas and dark areas in a piece of art.

# The Elements of Art IN ACTION

Let's look at one of my doodles and see what Elements of Art are here. Even though this is just a simple black and white drawing, it has line, shape, and space. When you color it in, you'll probably add form, color, value, and maybe even texture. That's all seven Elements of Art—on a coloring book page! How cool is that?! Art truly is all around us!

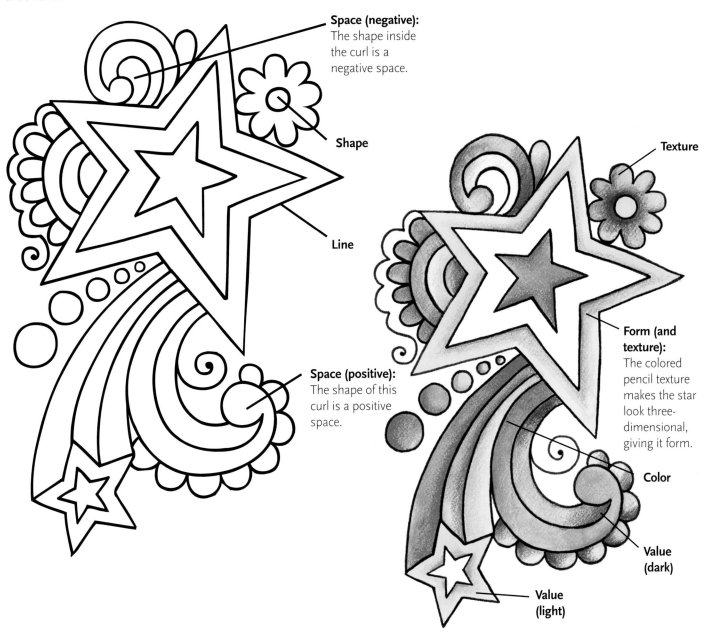

**Space (negative):** The shape inside the curl is a negative space.

**Shape**

**Line**

**Space (positive):** The shape of this curl is a positive space.

**Texture**

**Form (and texture):** The colored pencil texture makes the star look three-dimensional, giving it form.

**Color**

**Value (dark)**

**Value (light)**

# Get inspired by COLOR

When it comes to expressing emotion, I think color is probably the most powerful Element of Art. To me, there's no better way to express how you're feeling, or how you want someone else to feel, than through the use of color. Just think of some of your favorite memories and how they make you feel. I bet color plays a big part of what you remember. Whether it's a beautiful sunset, the green of spring after a long, cold winter, or a perfectly clean, white expanse of snow, color makes a huge impact on us, both visually and emotionally. Just look at the way different colors can give the same flower drawing a completely different feel.

I've found that planning is key when working with color. If you're like me and you just **love** color, it might seem a bit overwhelming to get started. There are just so many color choices! And it's easy to fall into the rut of using the same colors over and over again, just because you like them. Making color decisions before you start can make you feel comfortable using new colors. Plus, you won't have to make a choice when you're in the midst of coloring and decide you don't like the result as much as you thought you would. A great way to try some new color combinations is to take a few minutes—it won't take long!—to create your own palettes before you get started.

Here's a fun trick I've learned for making palettes. It works especially well if you're using markers or colored pencils. Lay out all of your markers (or pencils) on a table or floor so you can see every single color you have. Pick one favorite marker (pencil) that will serve as the **anchor color** for your palette. Make it a color you really enjoy working with (or for a challenge, maybe a color you never work with). Now, pick two or three other markers (pencils) that complement your anchor color and place those next to your anchor color to start building a palette. Keep going until you have picked five or six colors. At this point, you don't even have to use them—you're just putting them side-by-side to see how the colors look together. Keep adding or switching colors until you like what you see. It's so easy to swap different colors in and out this way. Once you have a group of colors that you like, test them out on paper to make sure you still like the way they look together. If you love it, be sure to create a sample page with the names of the markers/colors you used so you won't forget. This is a great way to quickly create a whole library of color palettes for yourself.

Another great place to get color inspiration is literally from the world around you. Color is everywhere—your clothing, your bag, even a tissue box—there are probably patterns and designs with interesting color palettes surrounding you now! I'm sure there are things you bought because you liked the colors, so use those things that you love as inspiration. I once bought a pack of hair elastics simply because they had the most beautiful combination of blues and purples. Almost anything, anywhere, can become a color inspiration, so always keep your eyes open!

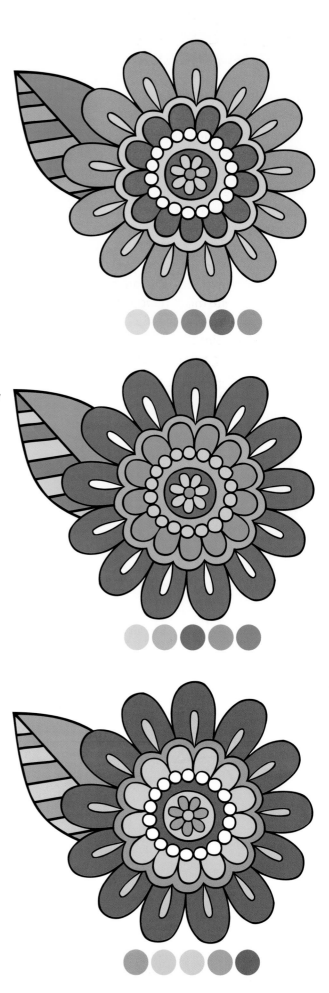

# A SPECTRUM of Emotion

Color can be a great way to express yourself and define your mood. When you sit down to color, ask yourself, "How do I feel today? How can I use color to express that feeling?" Sometimes you might even feel something you can't quite put into words, but you can express it with color.

I've included some of my favorite palettes on the following page. Each one is paired with the emotion that best describes how the color combination makes me feel. But keep in mind that everyone is different, and that's what makes art so exciting. I love to use bright colors, but maybe you like more subdued colors. My "relaxed" palette might be your "cozy." There is no right or wrong when it comes to color! Use these palettes as a starting point and see how they make you feel. Try adding or taking away a color to customize the palette to reflect your taste and style. Then, make your own page full of YOUR favorite color palettes!

The next few pages contain some colored examples. You'll see two color palettes on each page, one at the bottom and one along the outer edge. The palette at the bottom shows the design's main colors in the large circles. The small circles show lighter colors (called tints) and darker colors (called shades) of those main colors. This is to give you the feeling of this palette and visually show which colors are dominant in the design (the bigger the circle, the more dominant the color).

Along the outer edge of each page, I've included a palette with each individual color, shown separately, so you can easily match your marker, pencil, or paint colors to the colors I used.

Whether you use one of my palettes or create your own, always be sure the colors you choose reflect who you are and how you're feeling.

Now go gather up your art supplies—it's time to color!

The circles along the outer edge of the gallery pieces show you each individual color I used in that particular piece. If you like the palette I chose, you can use these circles to match the colors of your own pencils or markers.

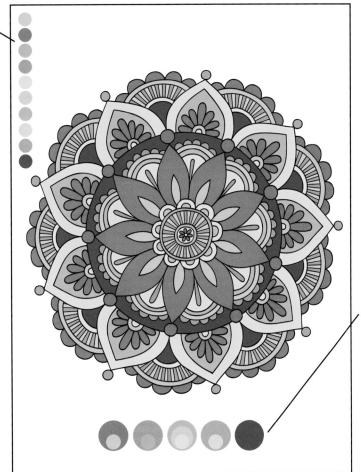

The circles along the bottom of the gallery pieces show you which colors are more dominant in each design. The larger the circle, the more dominant the color. The smaller circles show tints and shades of a main color that were introduced for variety.

# A SPECTRUM of Emotion

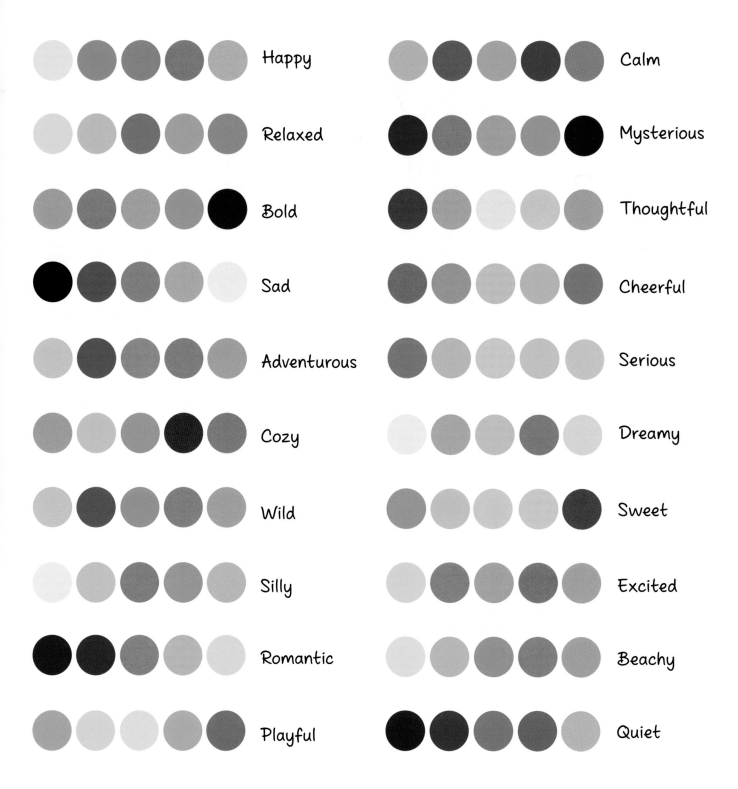

Happy

Calm

Relaxed

Mysterious

Bold

Thoughtful

Sad

Cheerful

Adventurous

Serious

Cozy

Dreamy

Wild

Sweet

Silly

Excited

Romantic

Beachy

Playful

Quiet

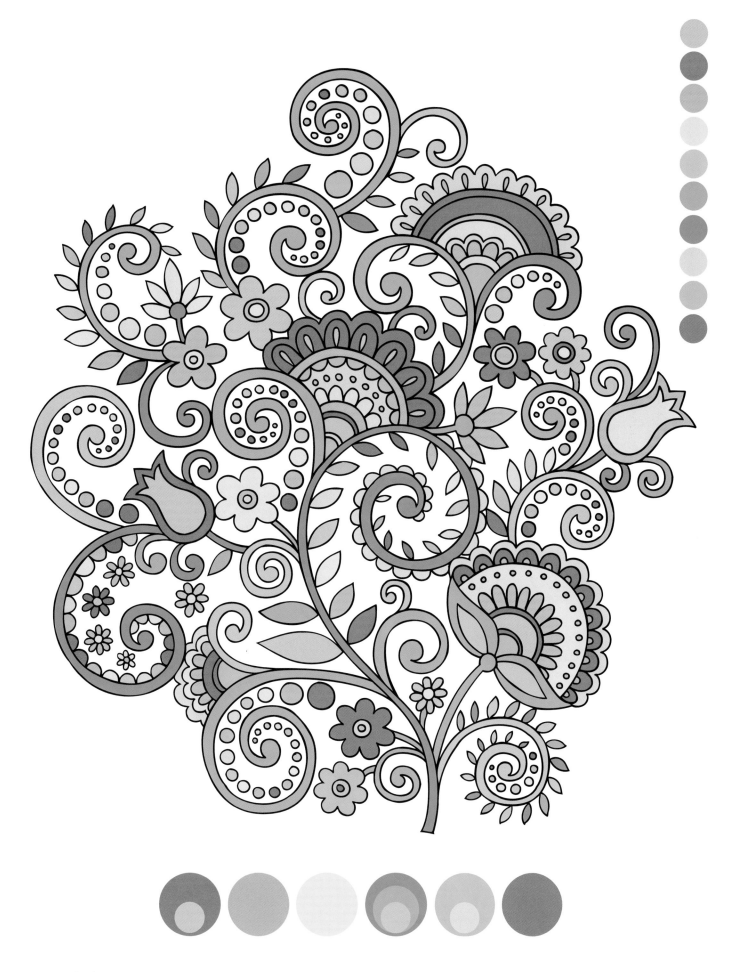

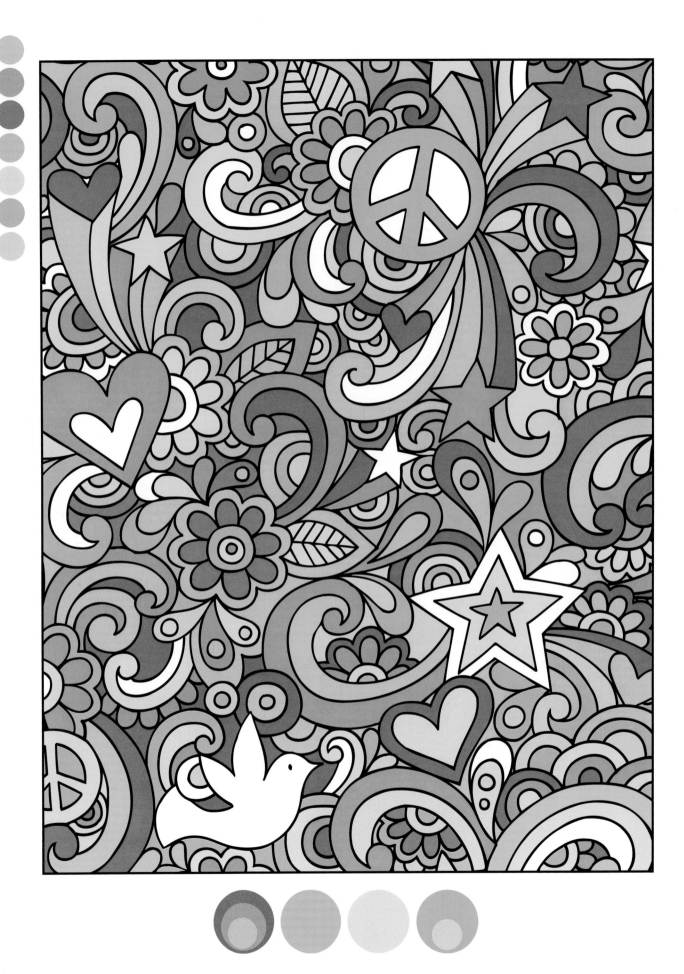

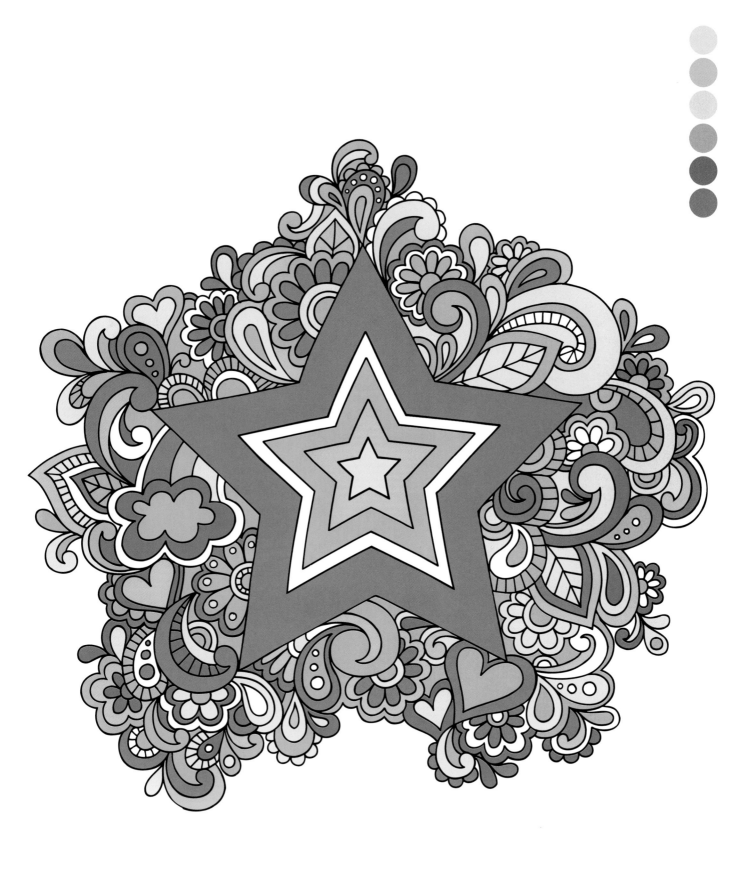

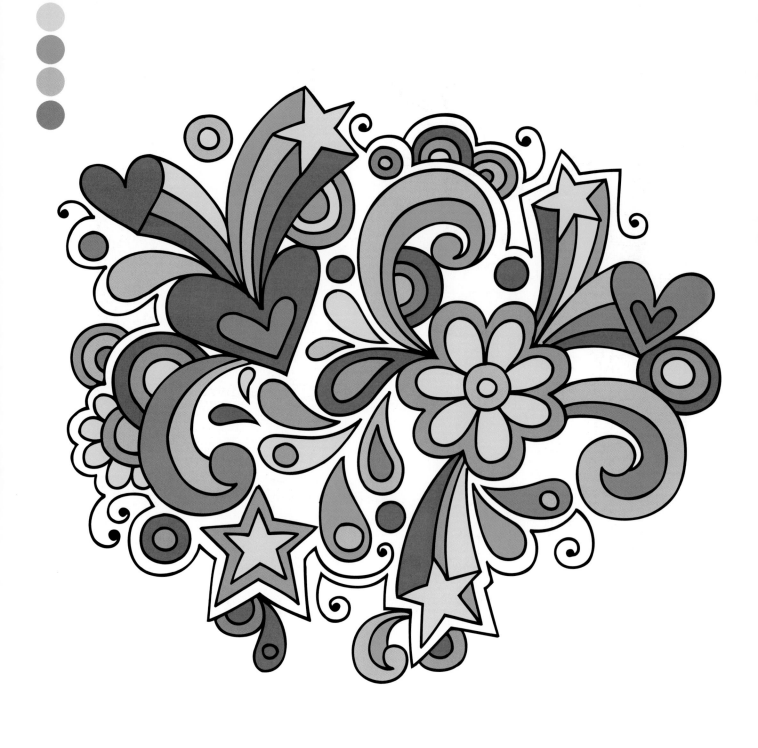

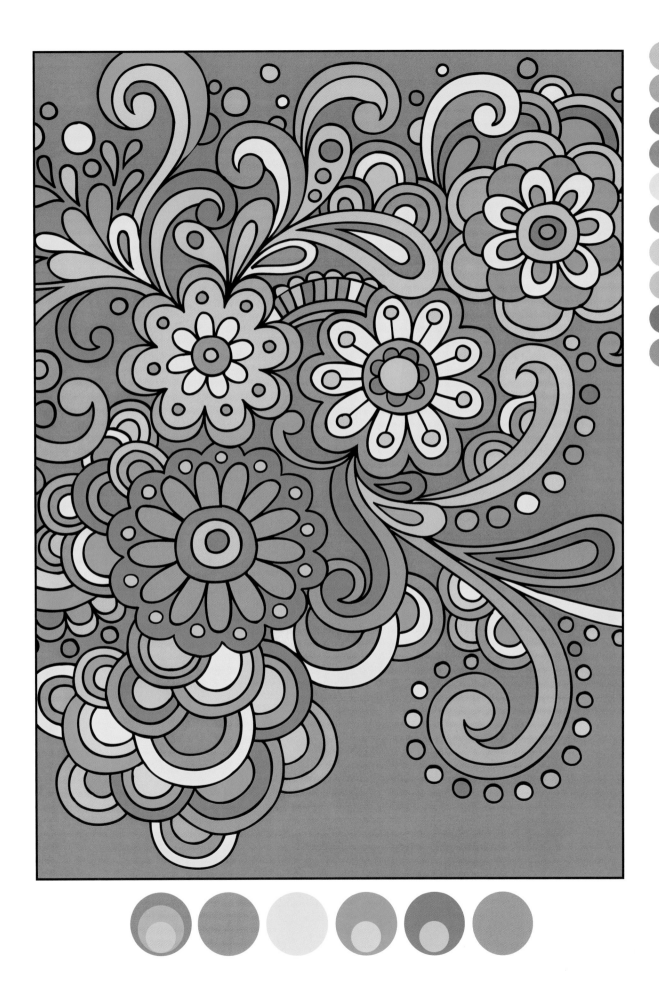

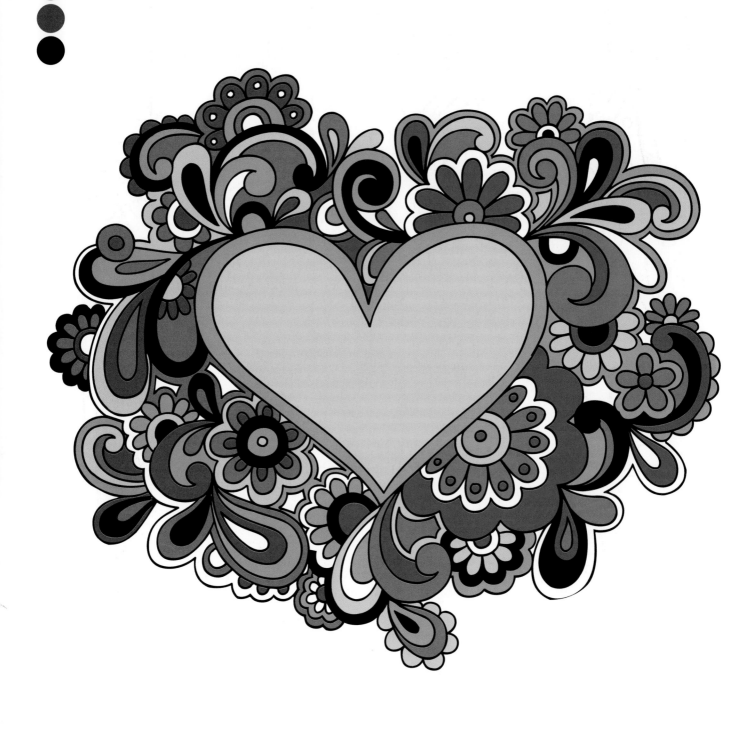

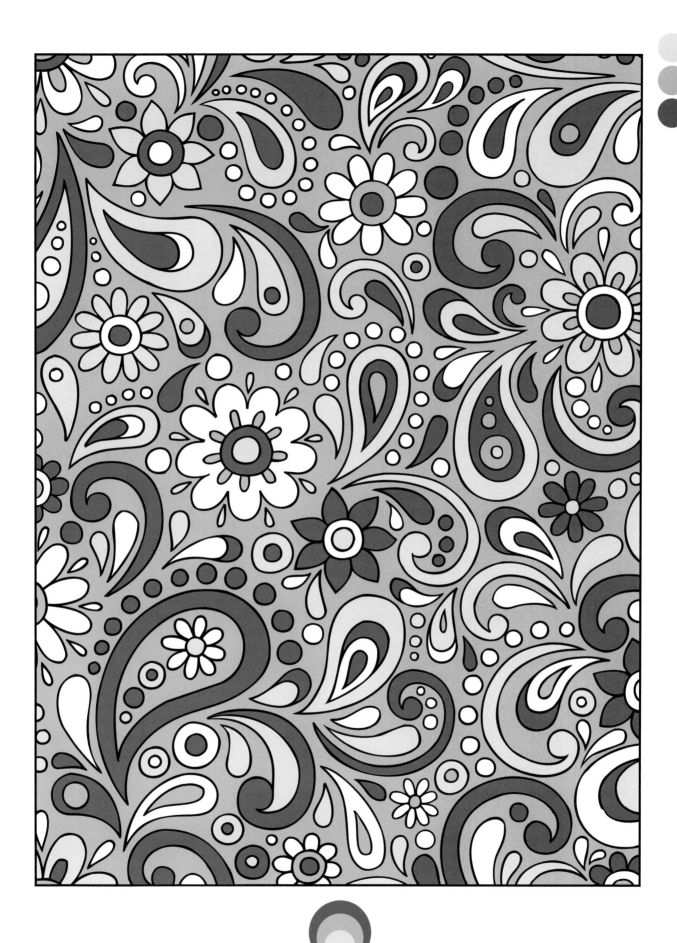

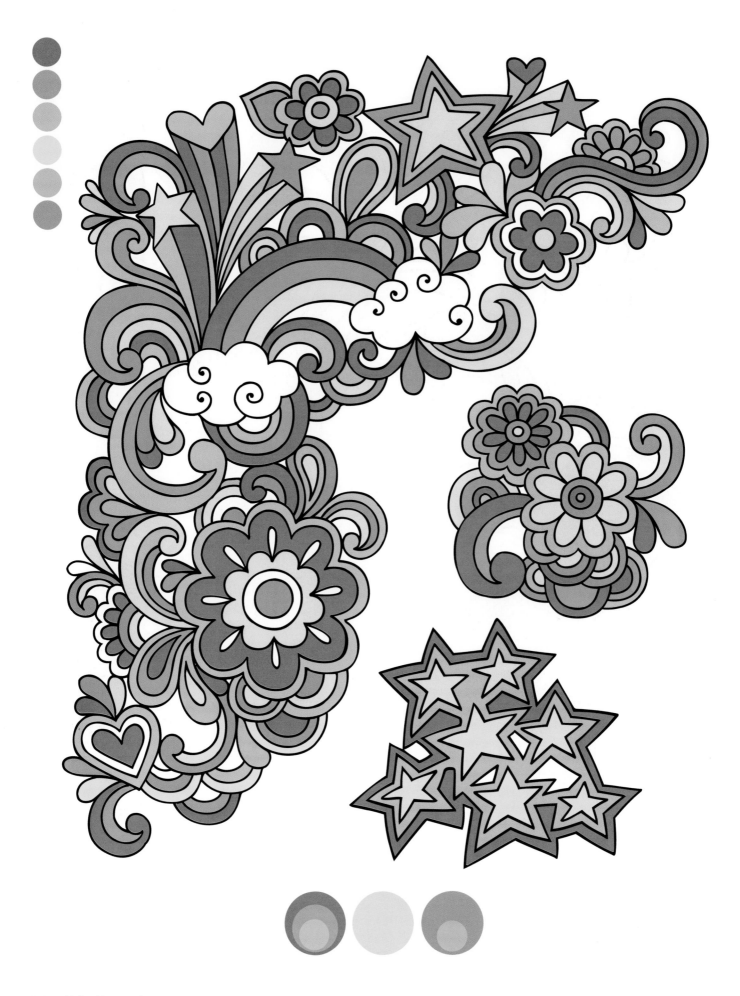

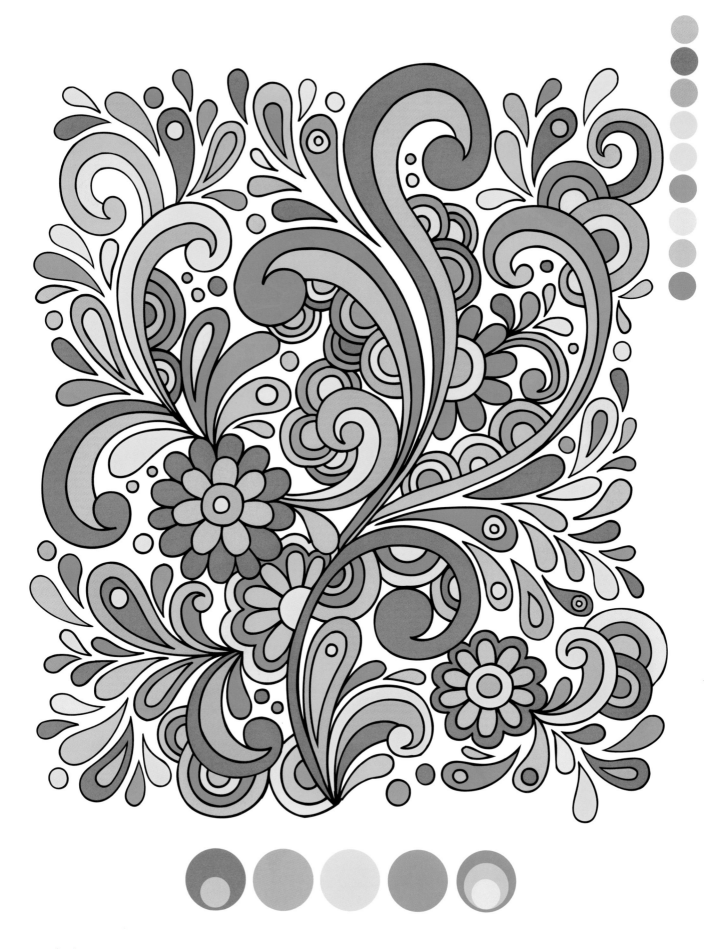

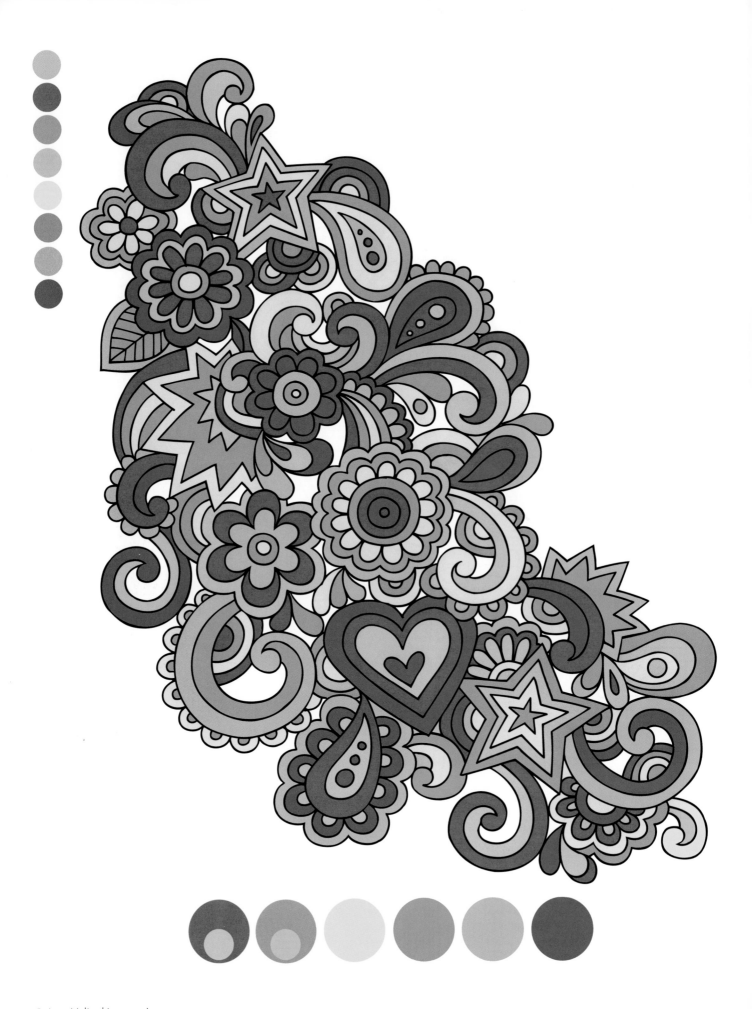

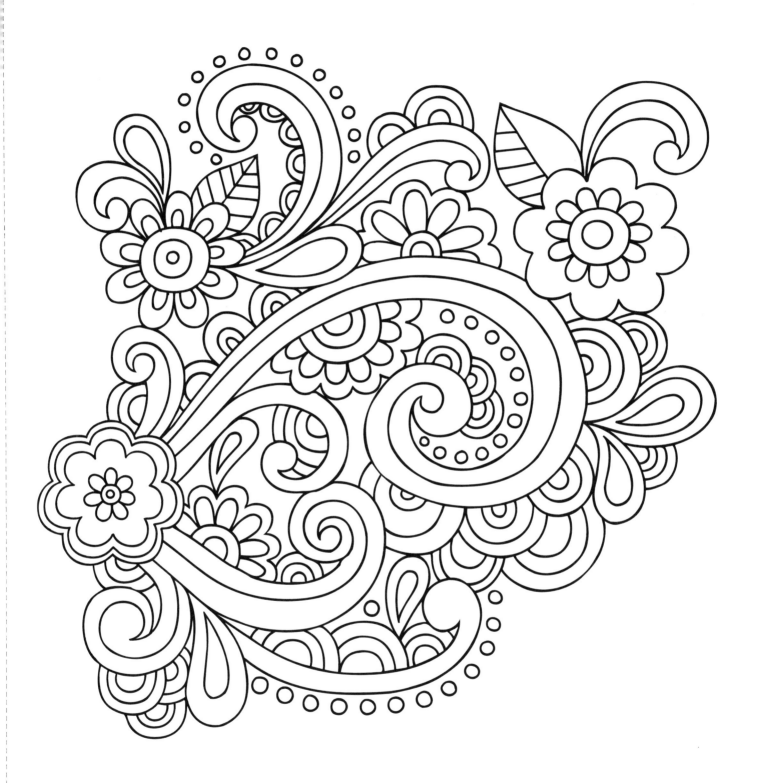

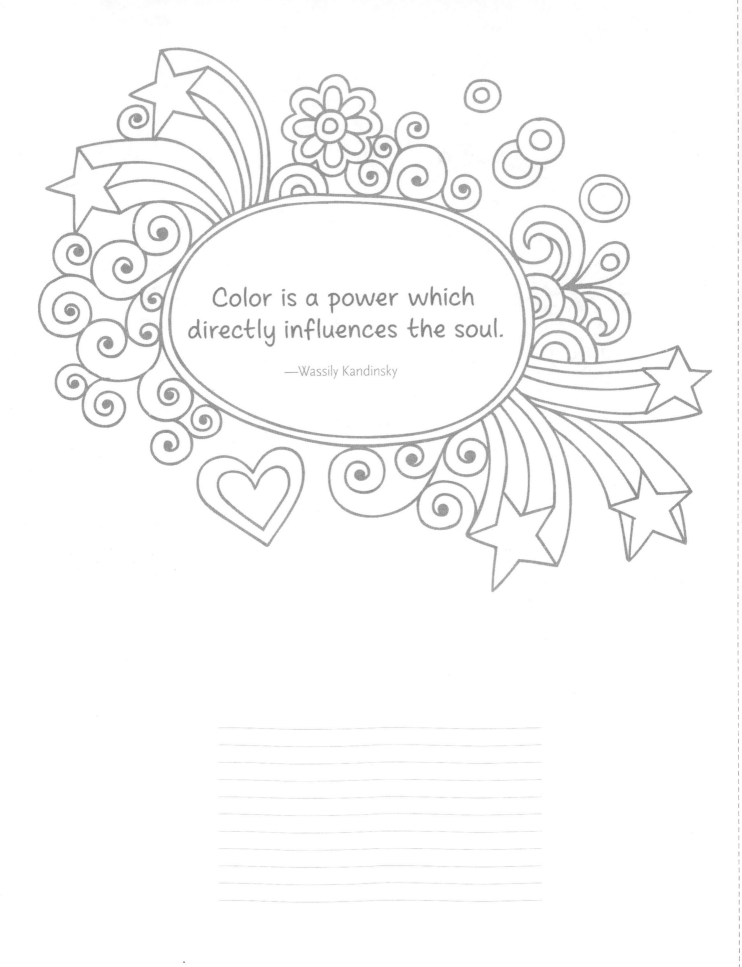

Color is a power which directly influences the soul.

—Wassily Kandinsky

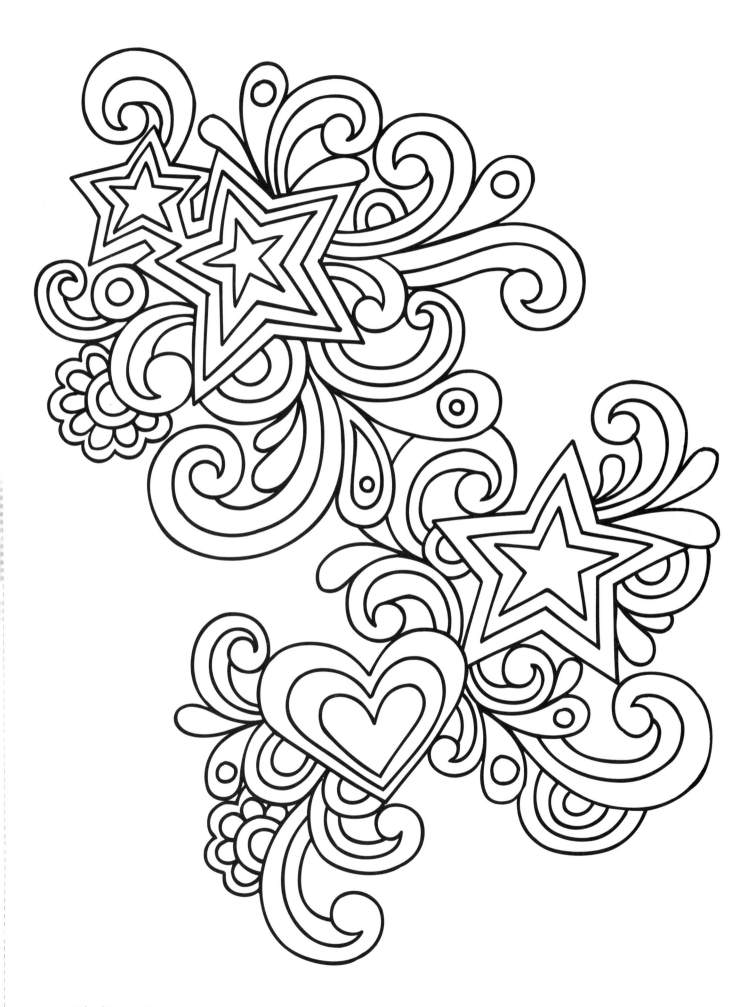

I found I could say things with color and shapes that I couldn't say any other way—things I had no words for.

—Georgia O'Keeffe

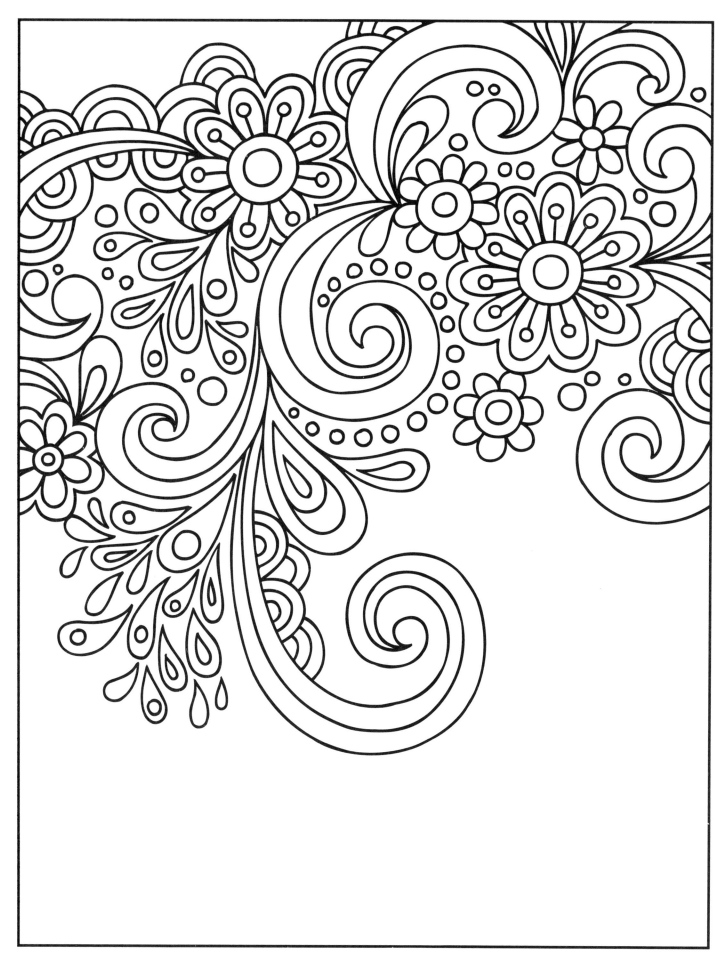

Extend the pattern to fill the page.

I dream my painting
and then I paint
my dream.

—Vincent van Gogh

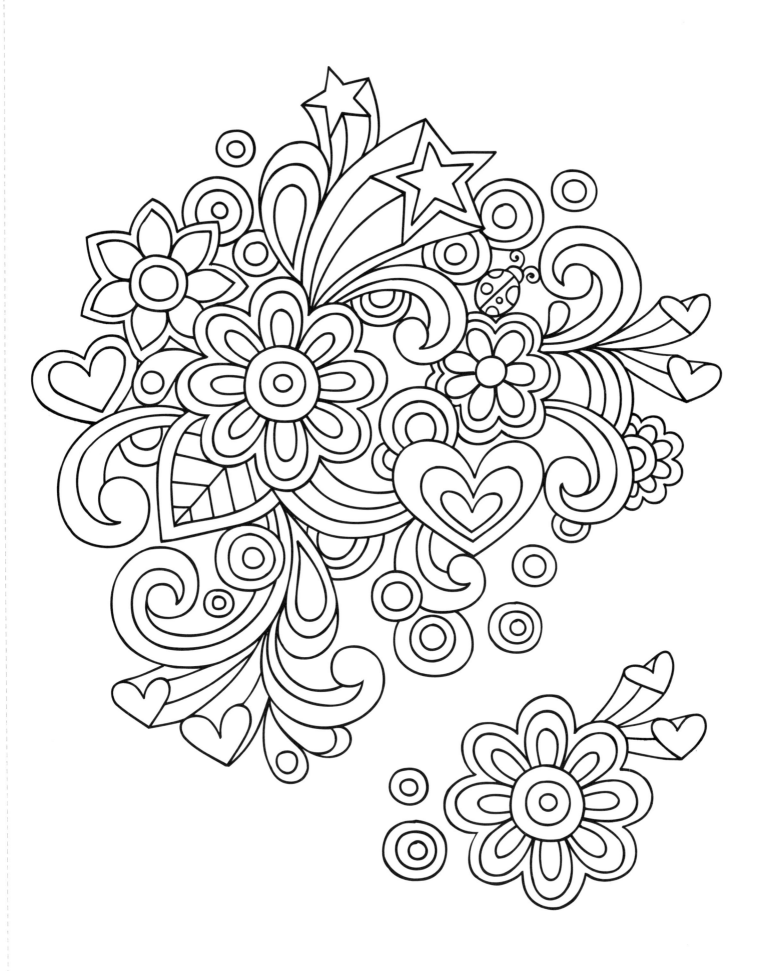

Art is anything you can get away with.

—Unknown

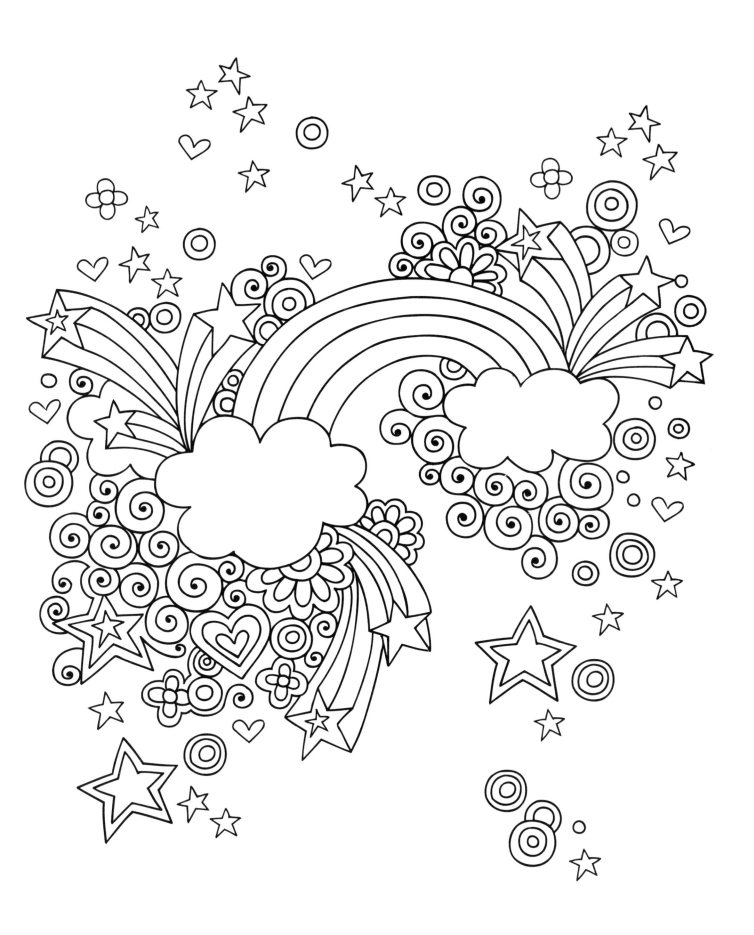

Art washes away
from the soul the
dust of everyday life.

—Pablo Picasso

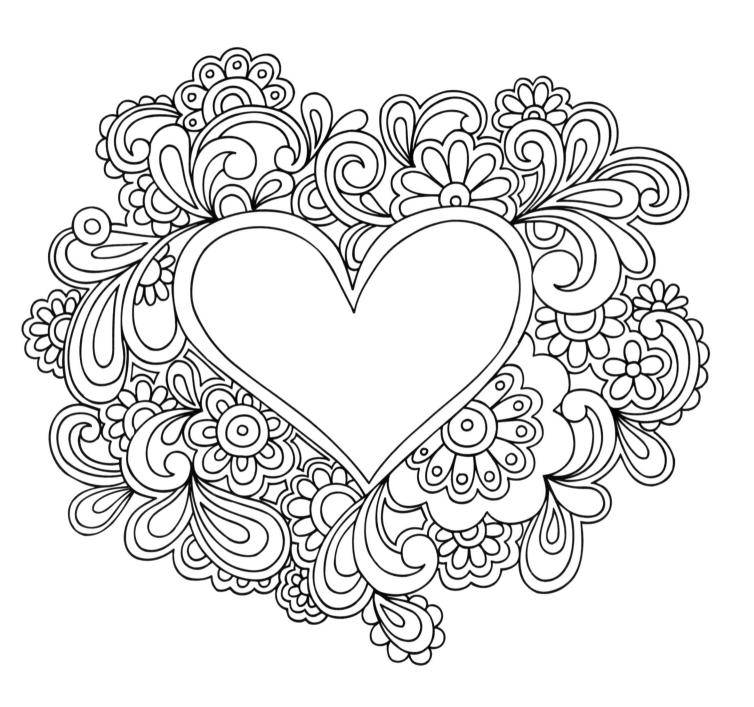

In our life there
is a single color, as
on an artist's palette,
which provides the
meaning of life and art.
It is the color of love.

—Marc Chagall

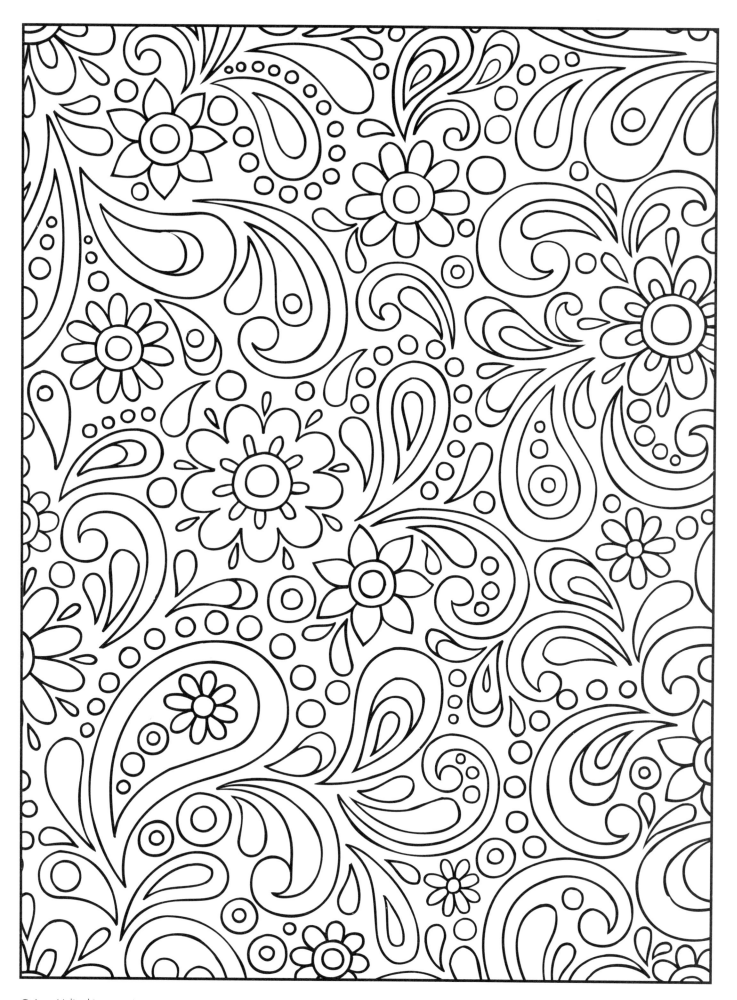

Color is the place where
our brain and the universe meet.

—Unknown

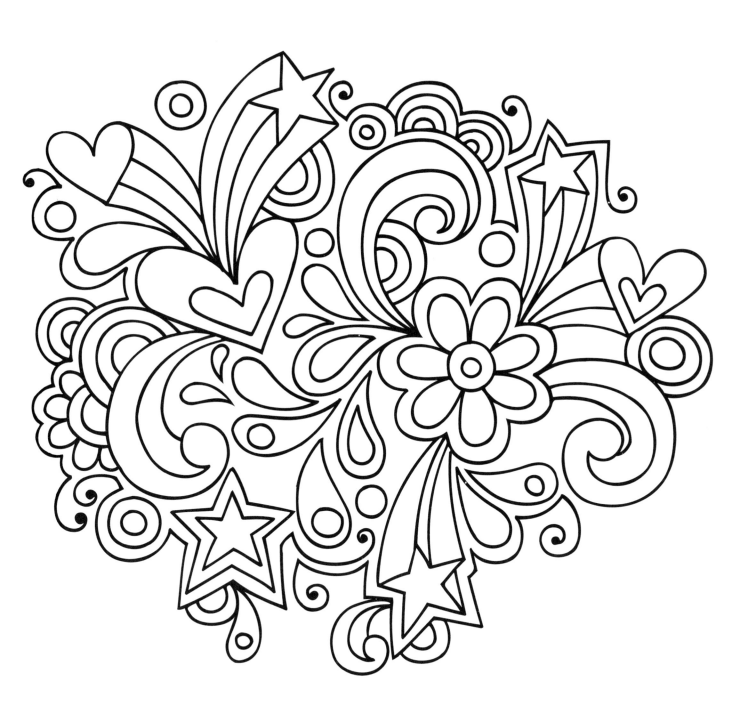

Filling a space in a
beautiful way.
That's what art
means to me.

—Georgia O'Keeffe

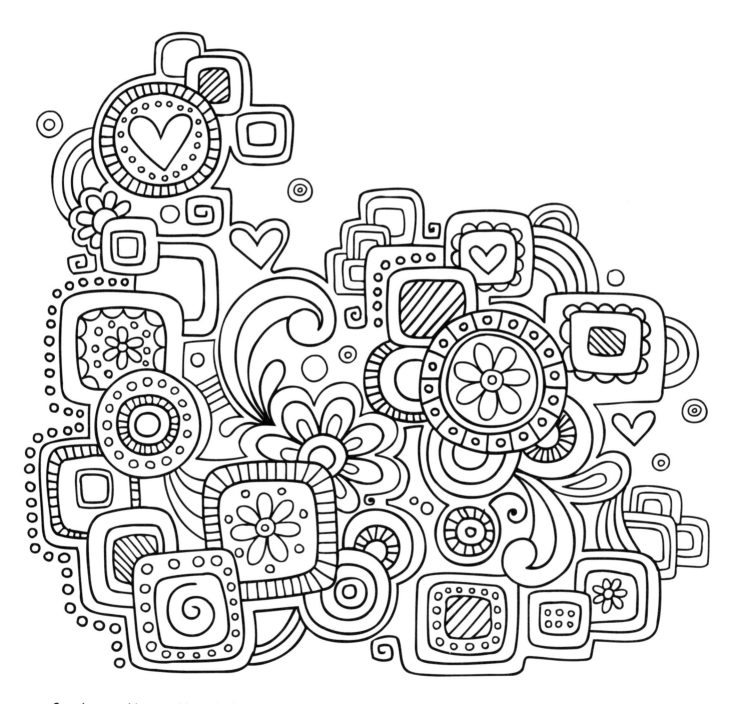

Continue the pattern! Add your own doodles to fill in the top part of the page.

Color! What a deep and mysterious language, the language of dreams.

—Paul Gauguin

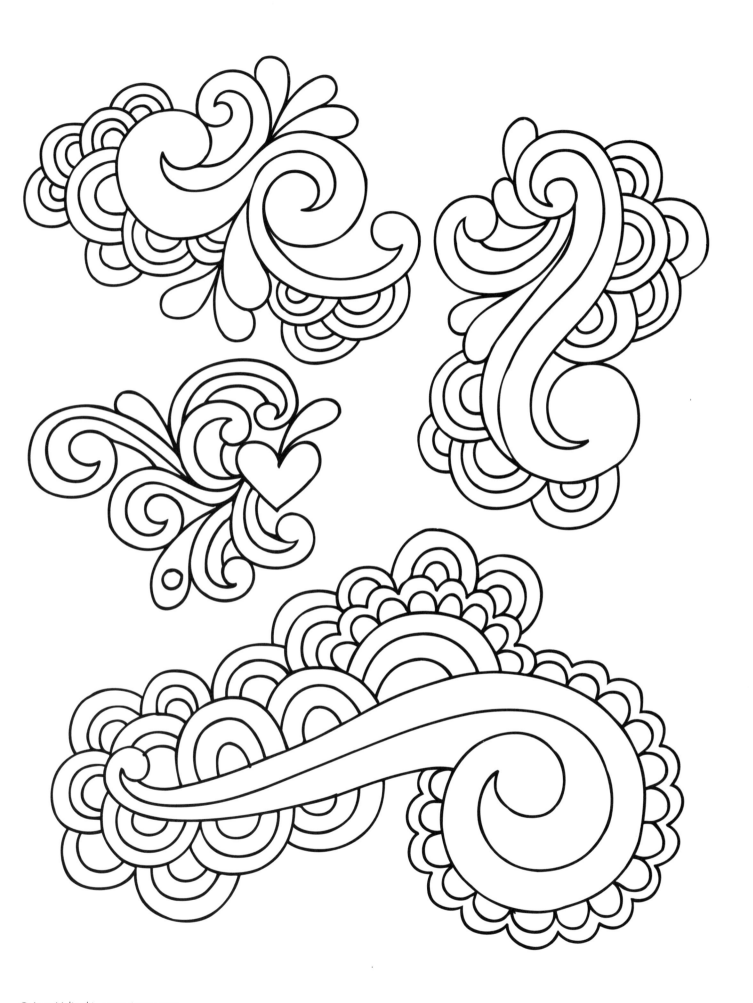

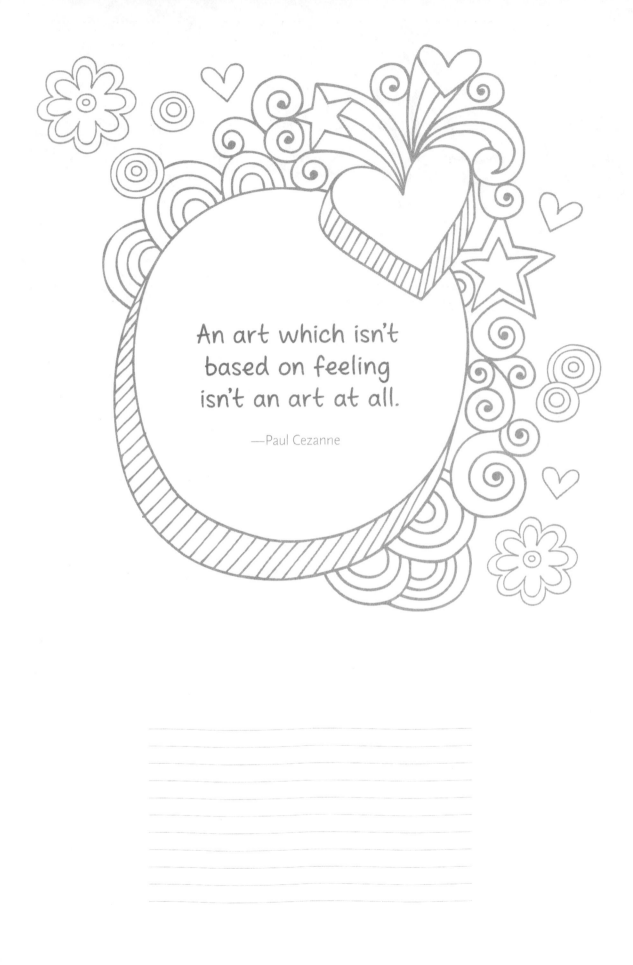

An art which isn't based on feeling isn't an art at all.

—Paul Cezanne

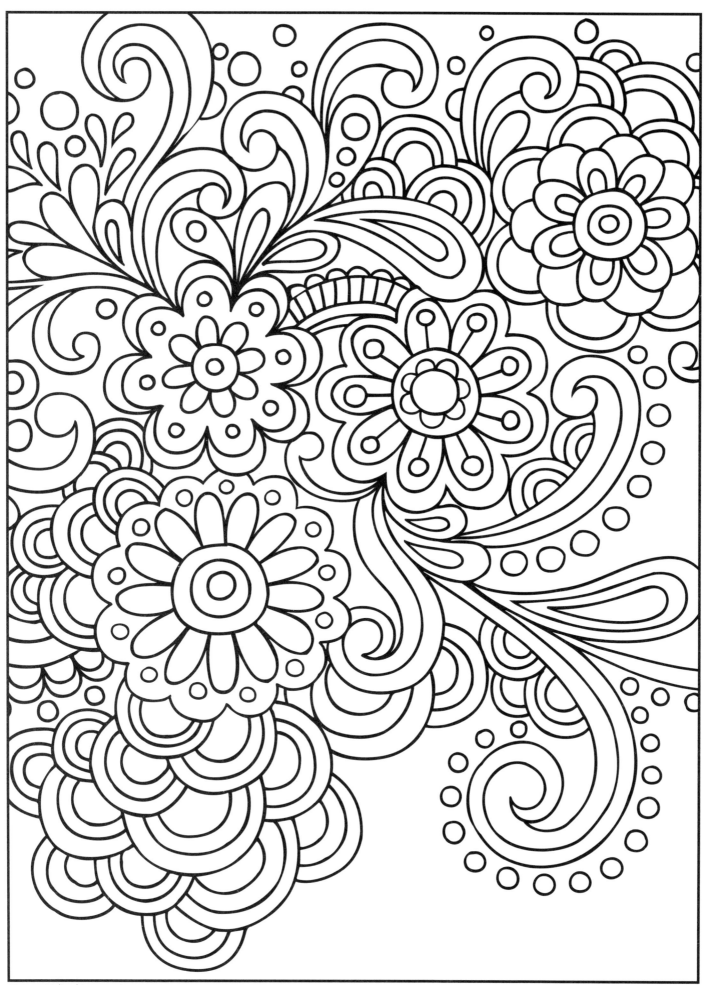

To be an artist is
to believe in life.

—Henry Moore

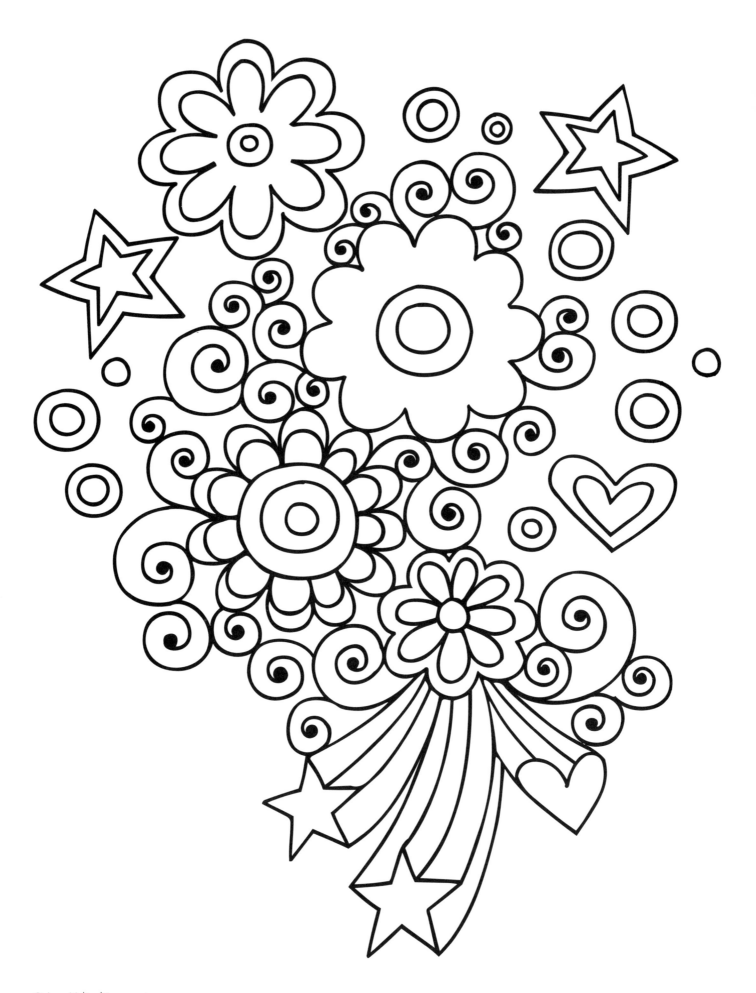

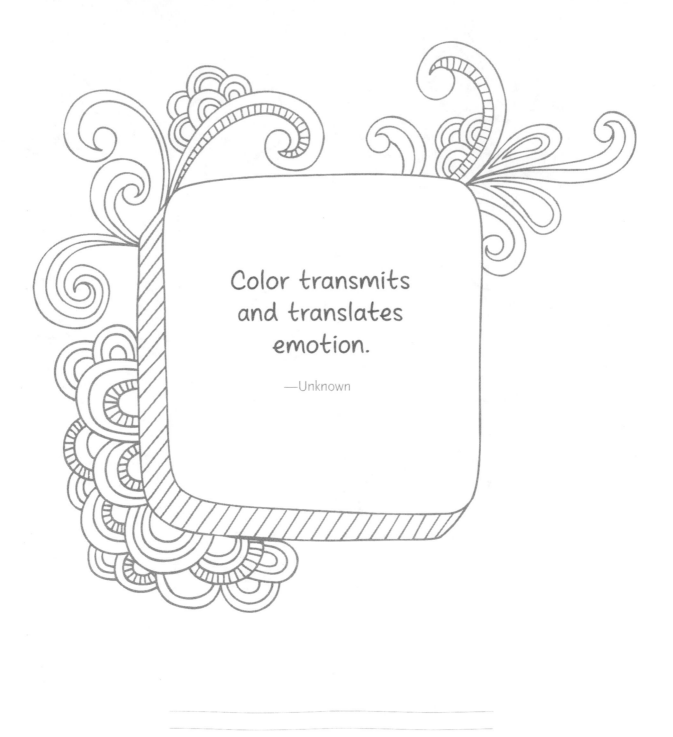

Color transmits and translates emotion.

—Unknown

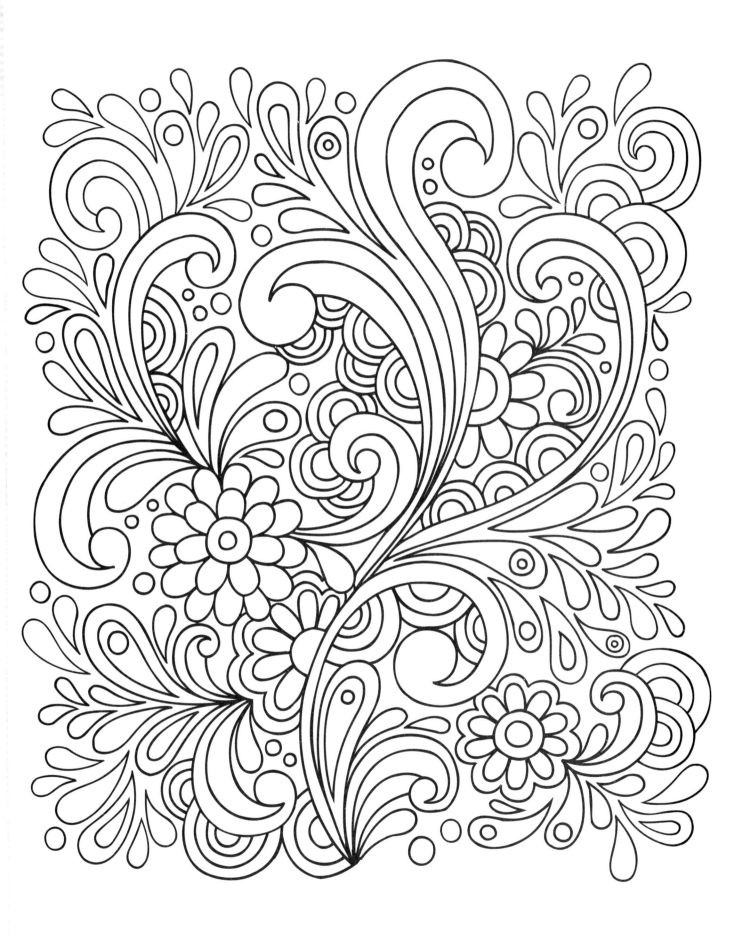

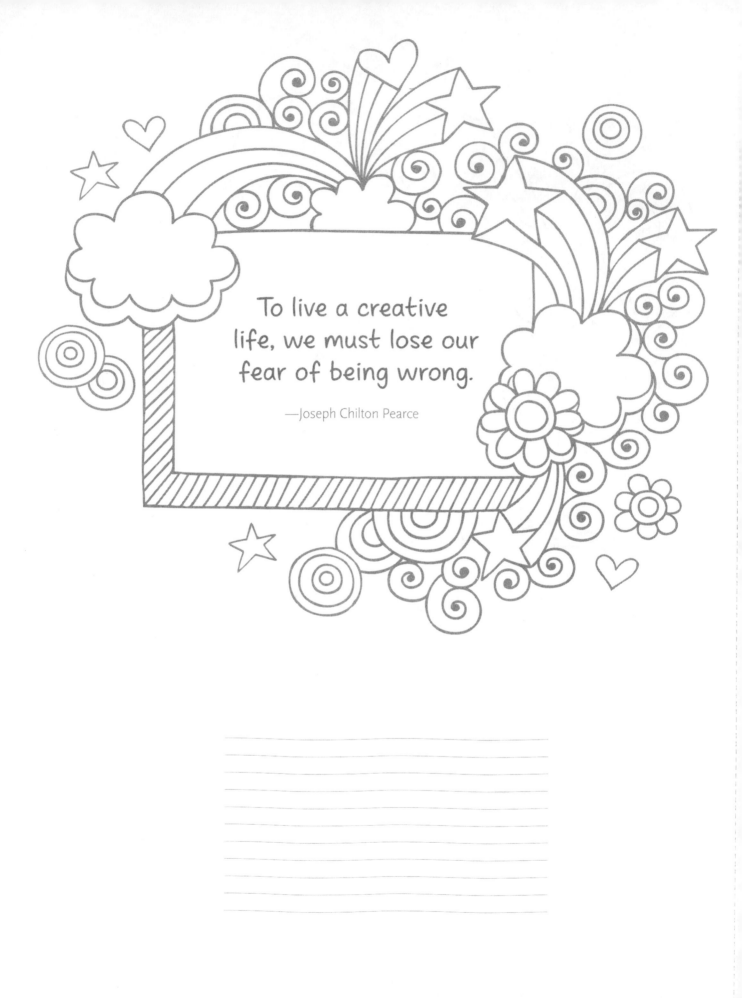

To live a creative
life, we must lose our
fear of being wrong.

—Joseph Chilton Pearce

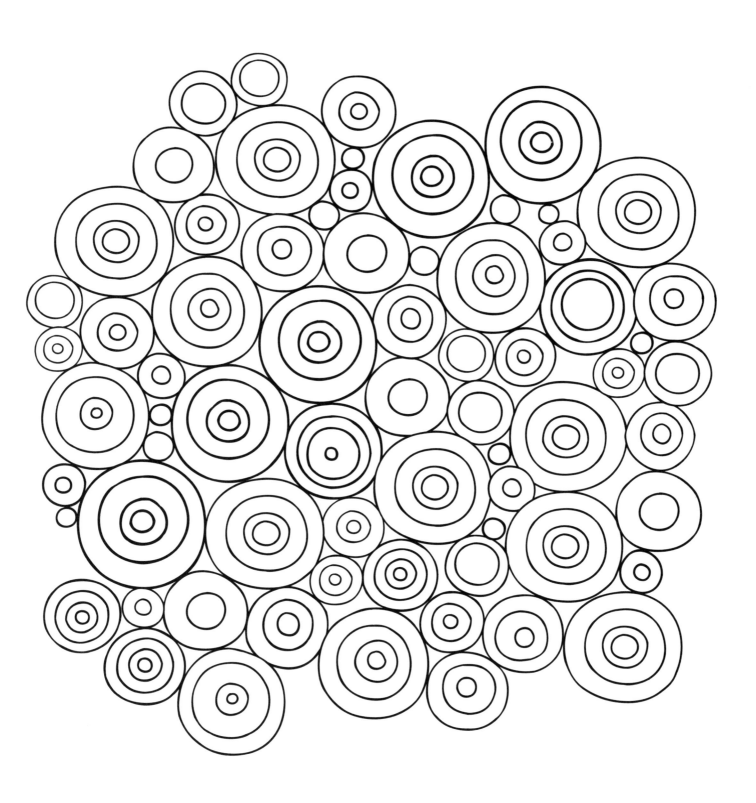

Extend the circle pattern to fill the entire page.

Create what sets your heart on fire and it will illuminate the path ahead.

—Karma Voce

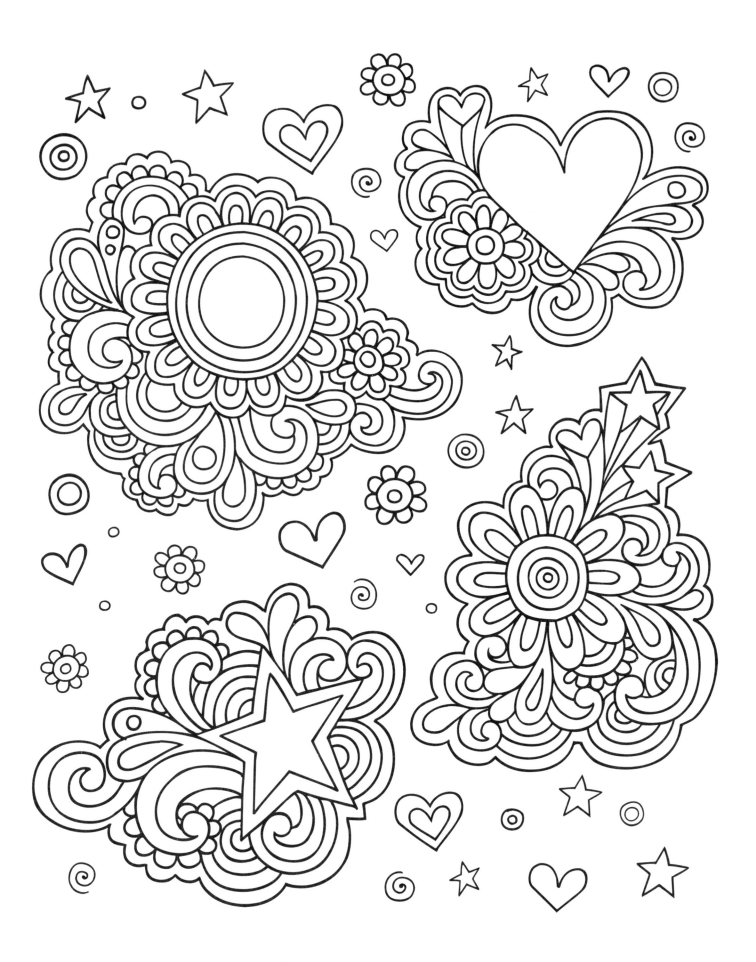

The "earth" without "art" is just "eh."

—Unknown

_____
_____
_____
_____
_____
_____
_____

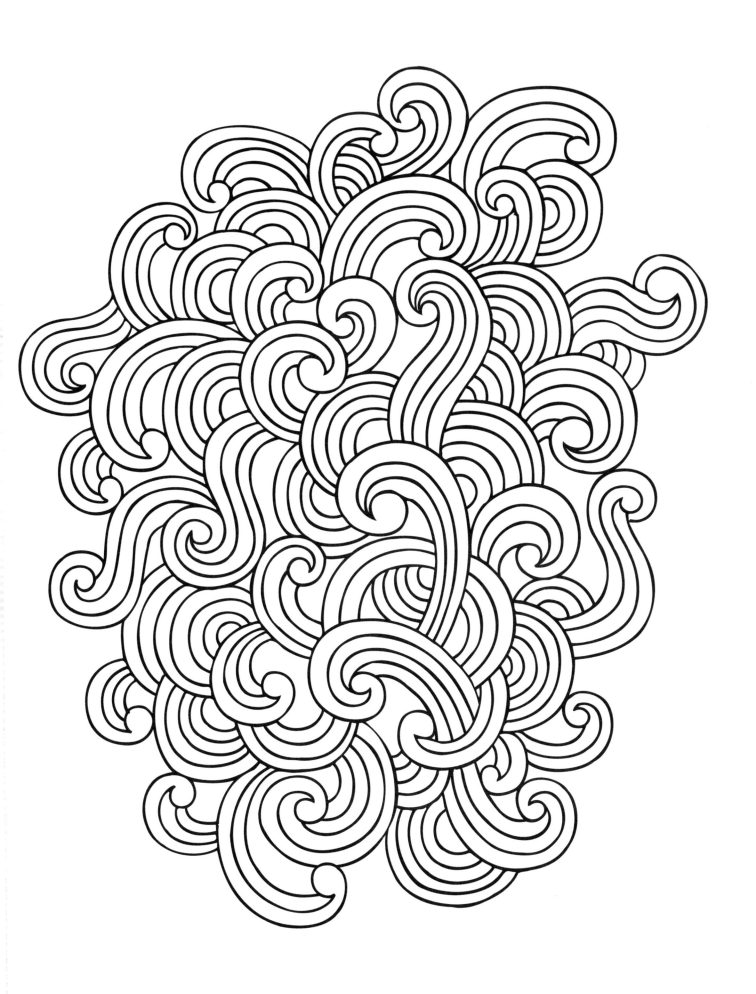

Creativity is allowing
yourself to make mistakes.
Art is knowing which
ones to keep.

—Scott Adams

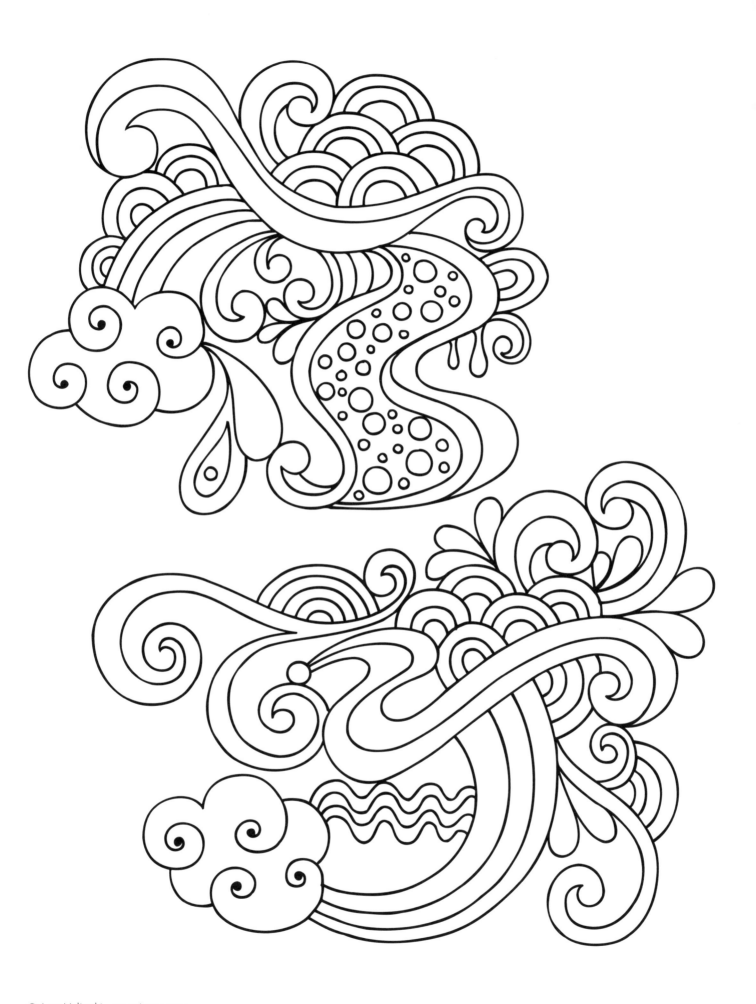

Art without color
would lose much
of its purpose.

—Unknown

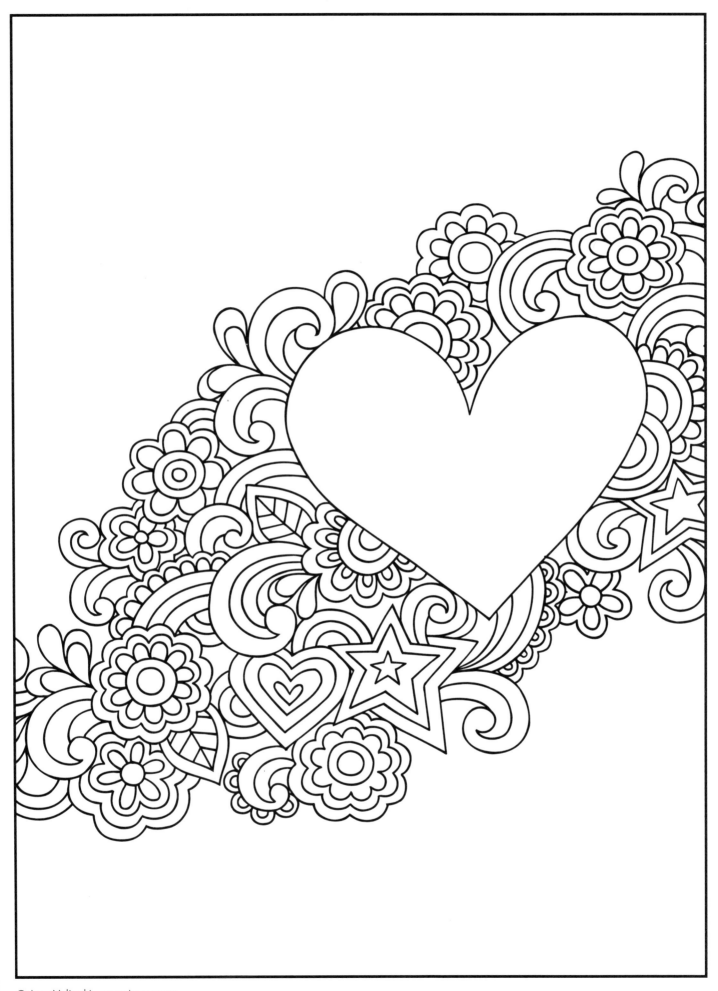

The soul becomes dyed with the color of its thoughts.

—Marcus Aurelius

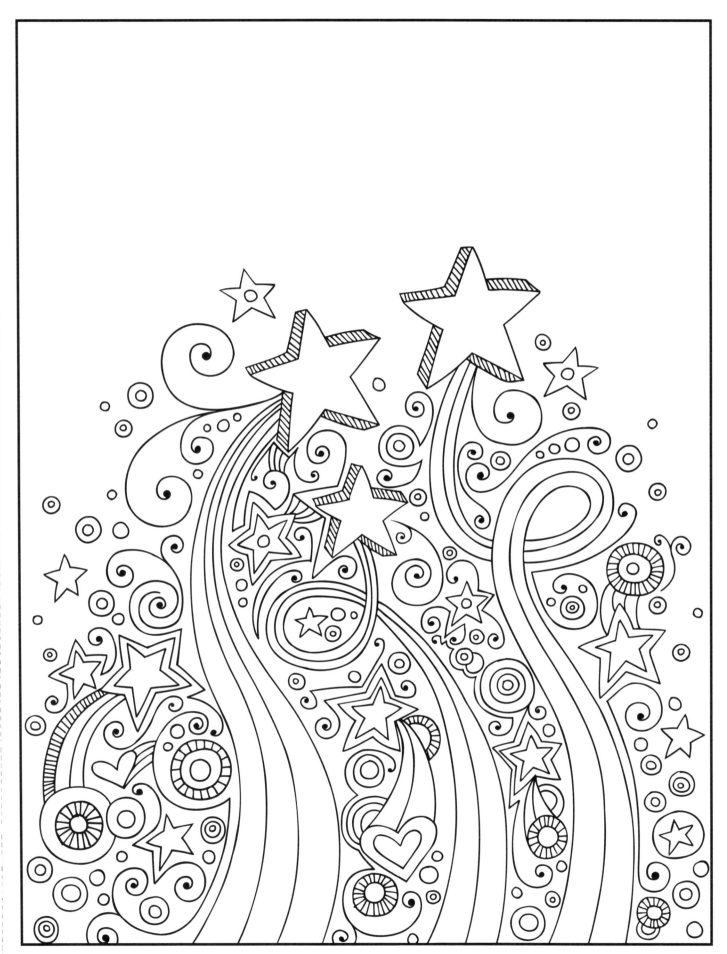

Fill in the empty space at the top of the page with your own doodley stars and circles!

If you could say it in words there would be no reason to paint.

—Edward Hopper

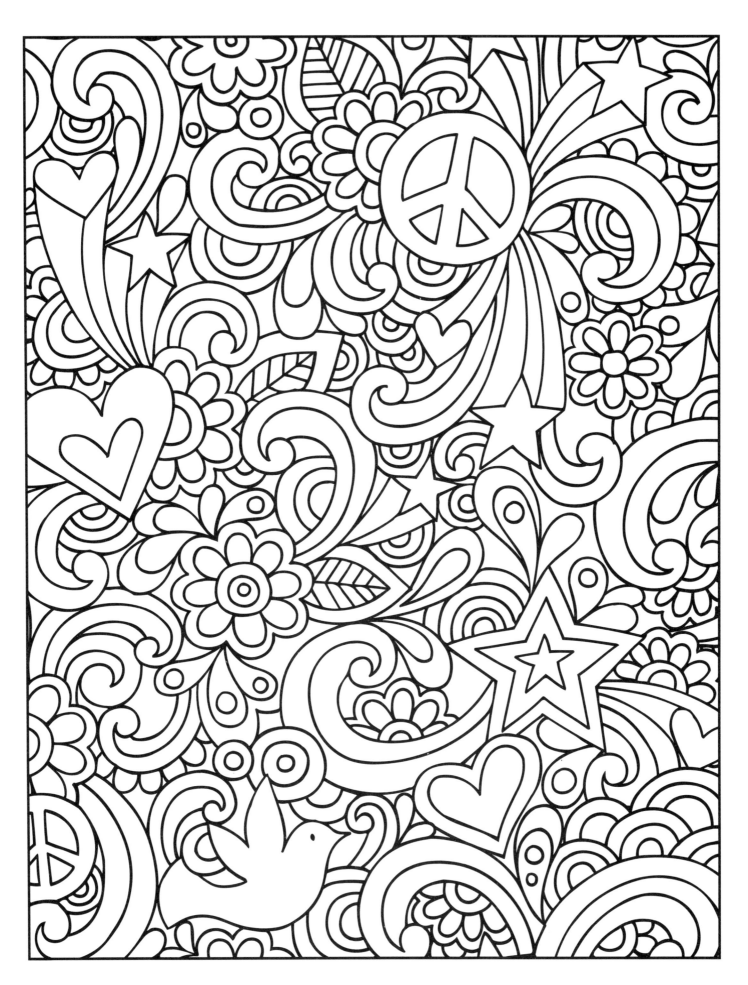

Sunset is still my favorite color, and rainbow is second.

—Mattie Stepanek

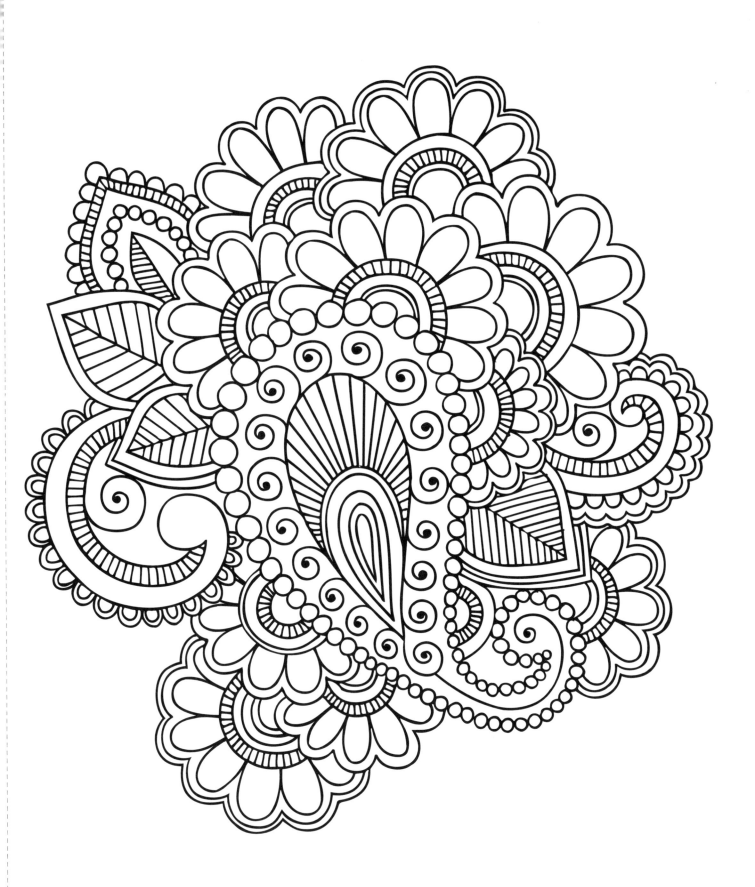

Do anything, but let it produce joy.

—Walt Whitman

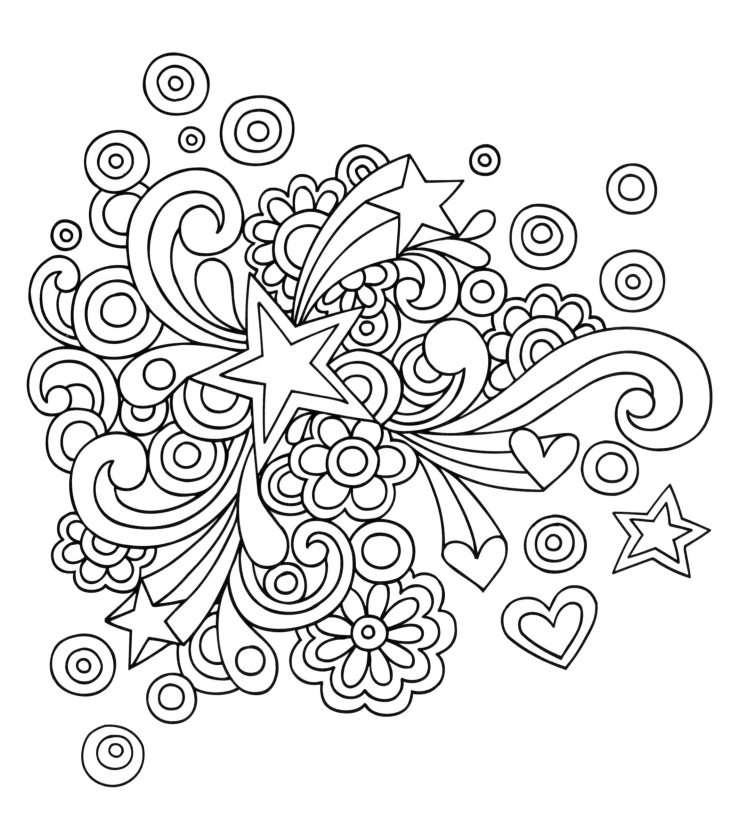

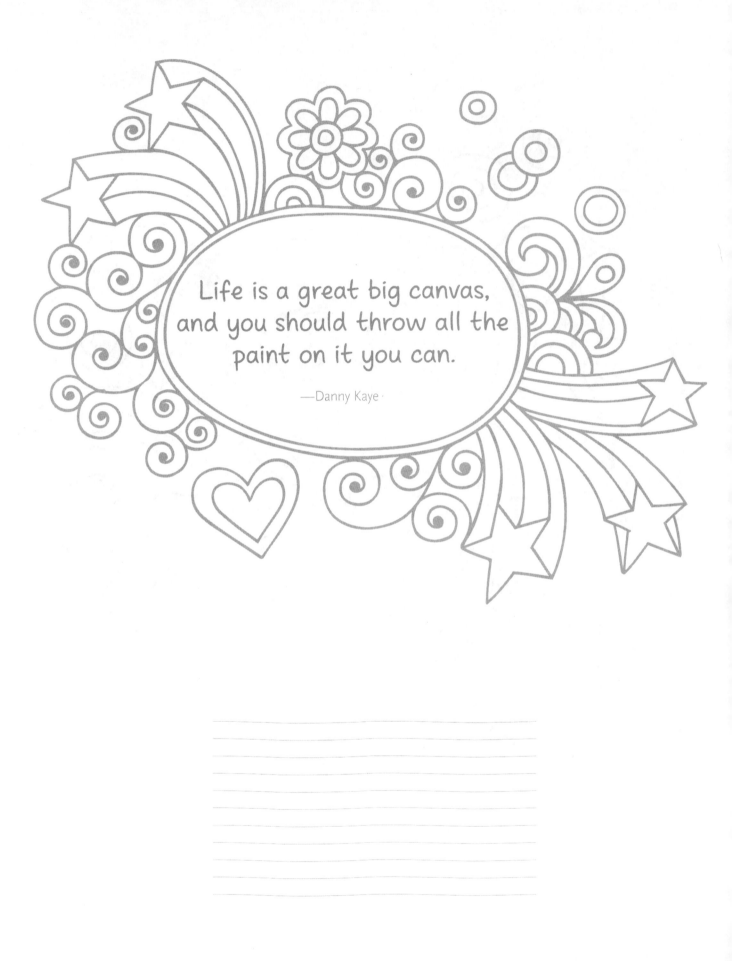

Life is a great big canvas,
and you should throw all the
paint on it you can.

—Danny Kaye

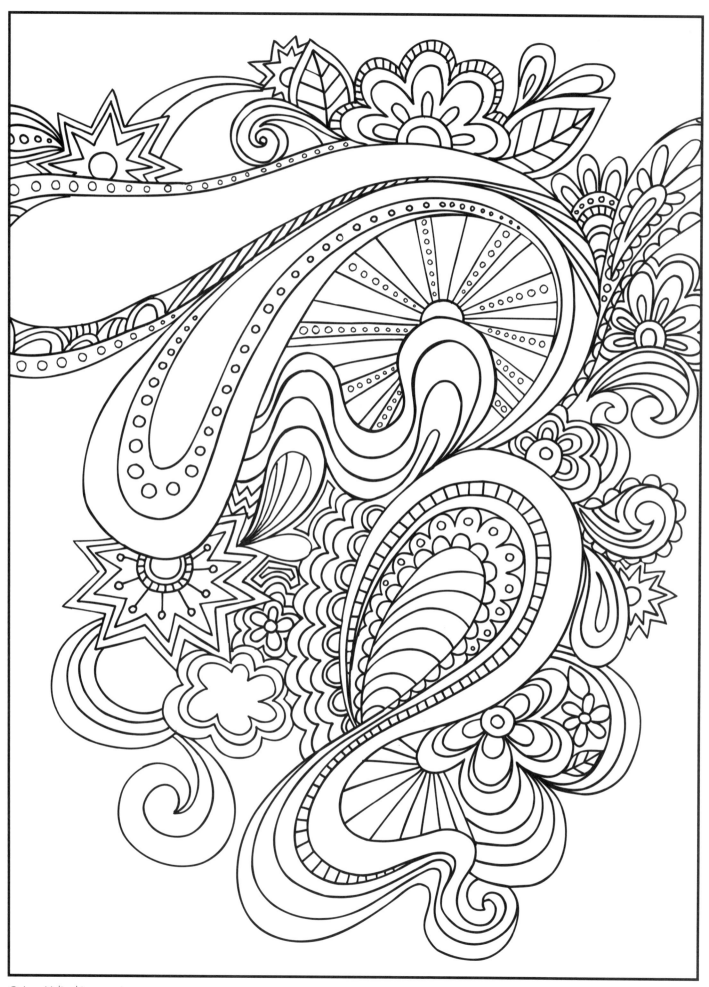

I paint with colors
that feed my soul.

—Catherine Jo Morgan

_____
_____
_____
_____
_____
_____
_____
_____

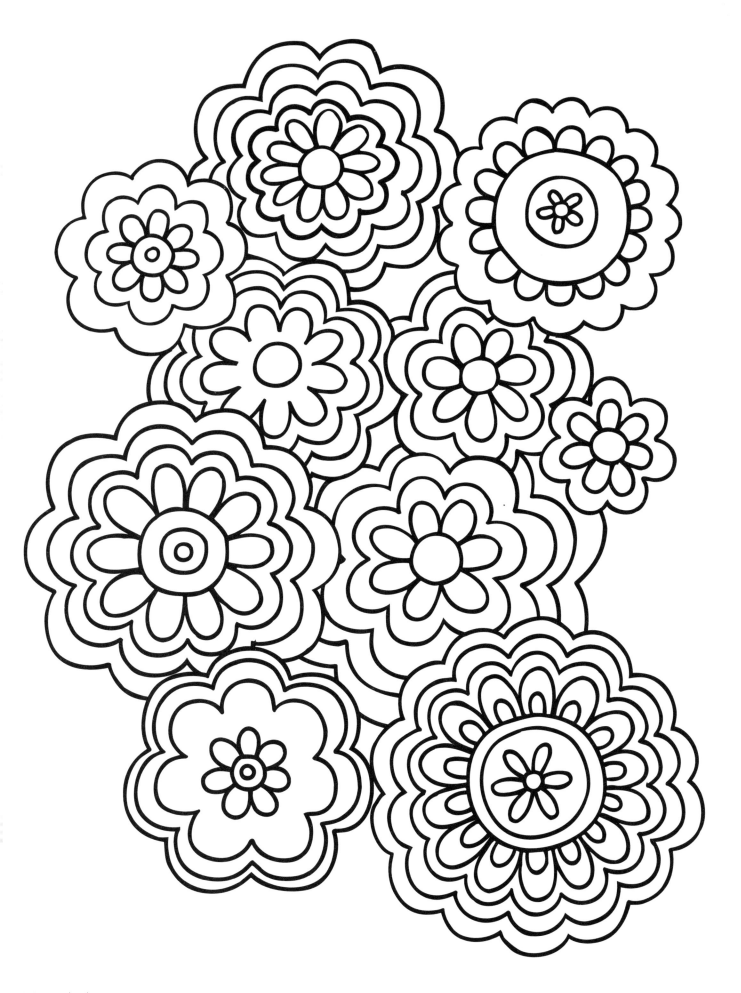

Learn the rules like a
pro, so you can break
them like an artist.

—Unknown

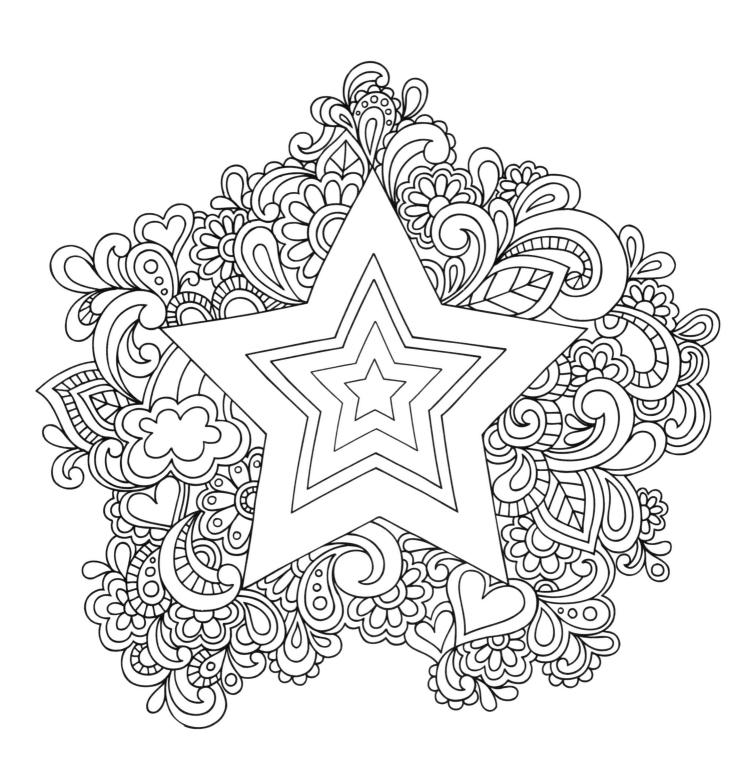

The main thing is to be
moved, to love, to hope,
to tremble, to live.

—Auguste Rodin

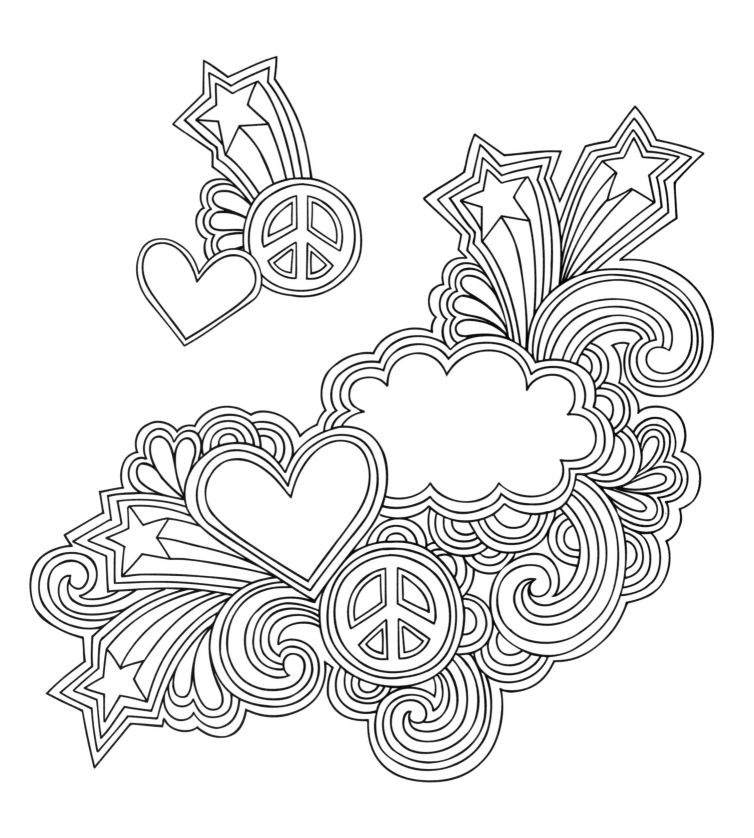

Color possesses me.

—Paul Klee

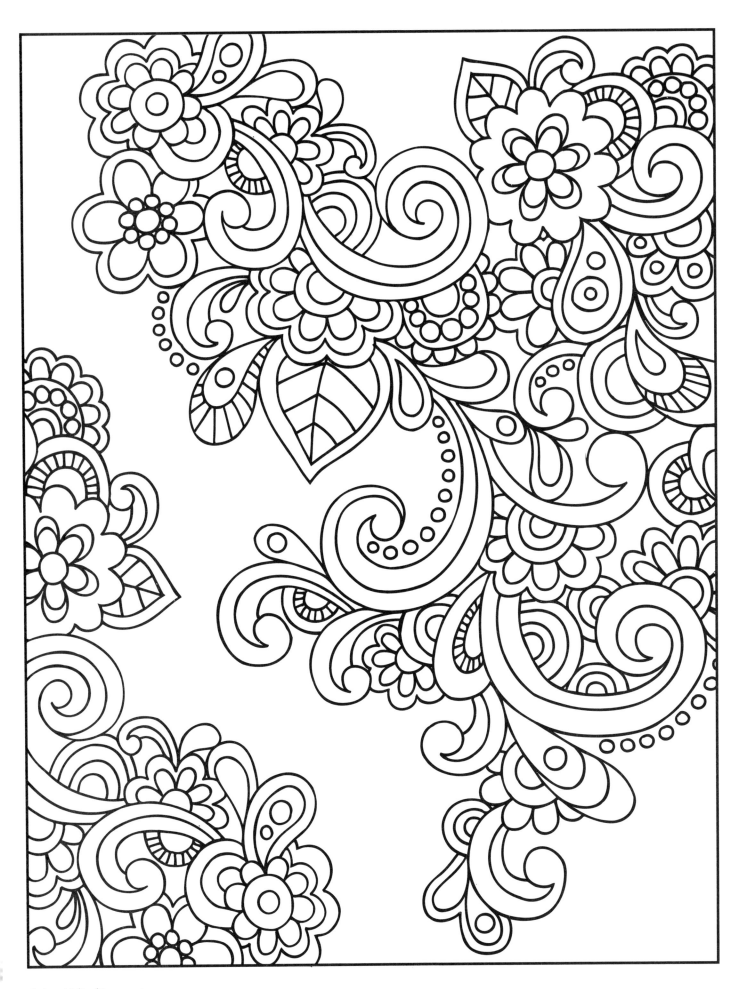

To draw, you must close your eyes and sing.

—Pablo Picasso

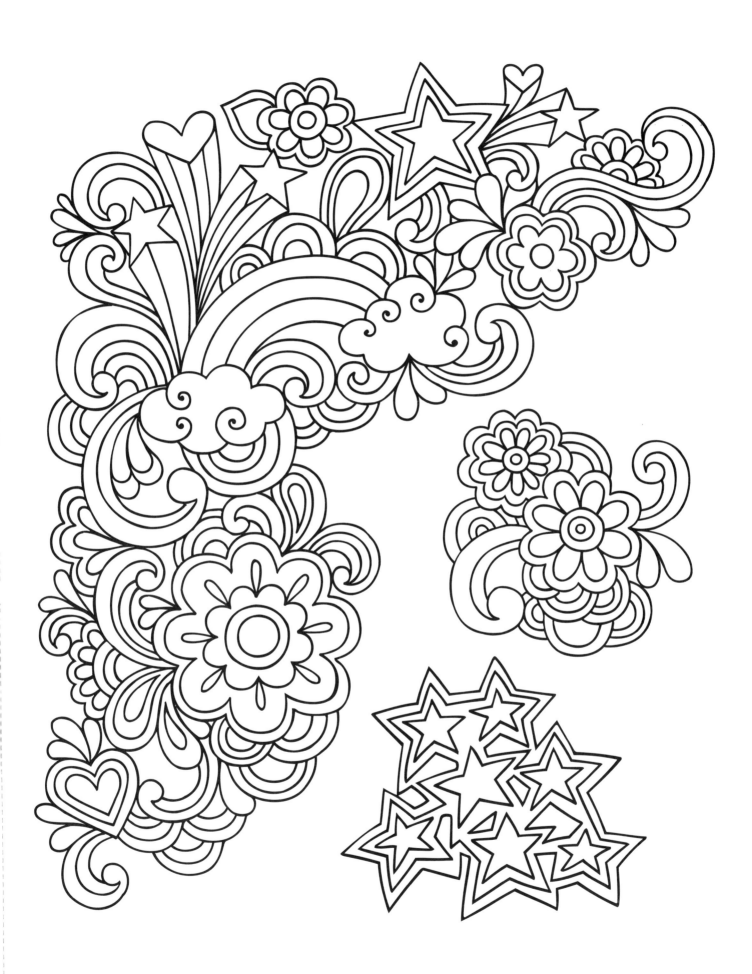

Art is when you hear a knocking from your soul—and you answer.

—Terri Guillemets

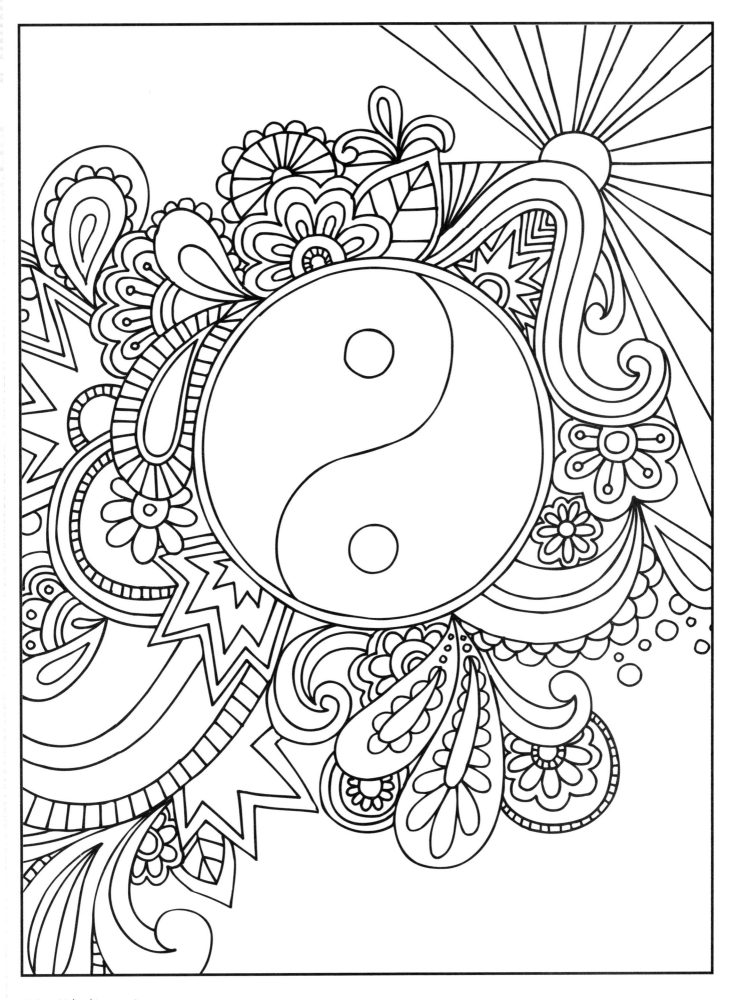

As music is the poetry of sound, so is painting the poetry of sight.

—James McNeill Whistler

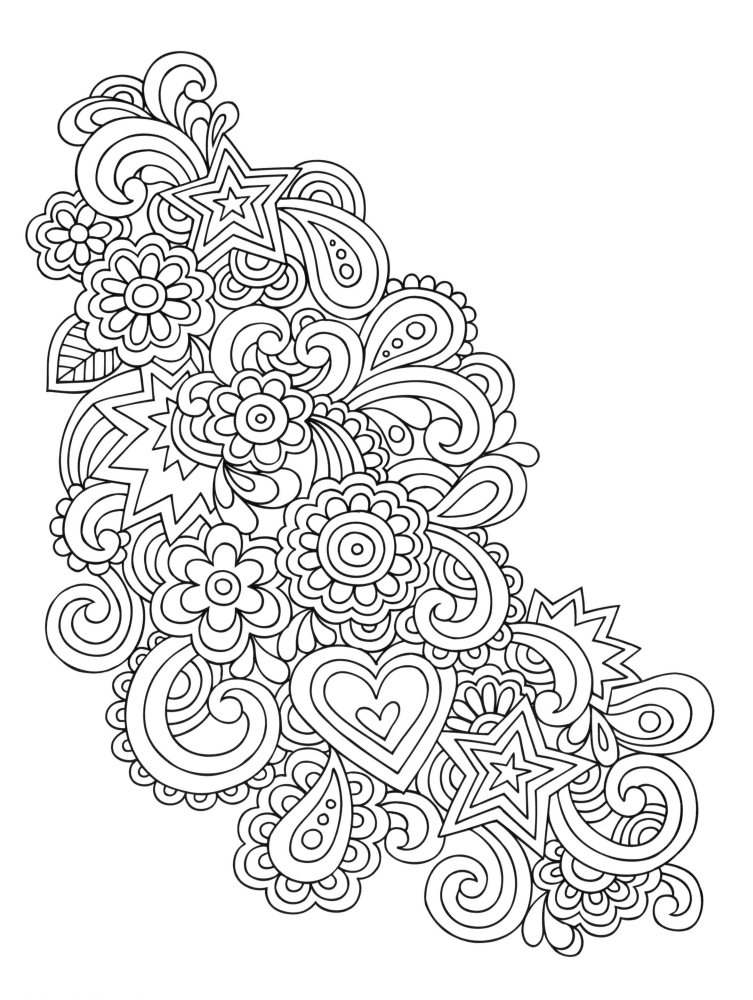

Every artist dips his brush in his own soul, and paints his own nature into his pictures.

—Henry Ward Beecher

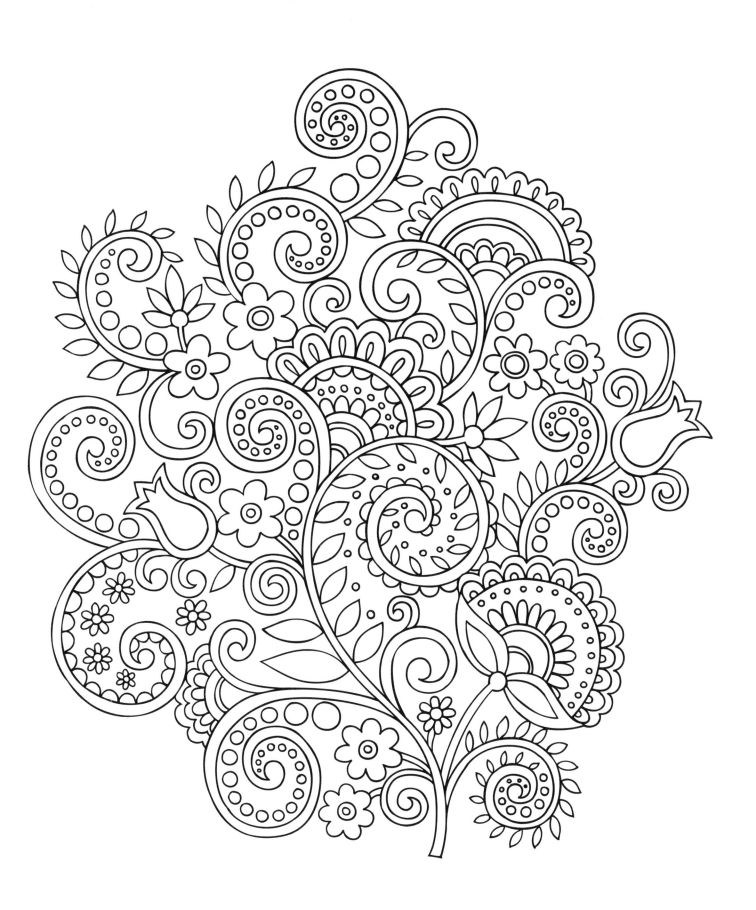

Fill your paper with
the breathings of
your heart.

—Unknown

---

---

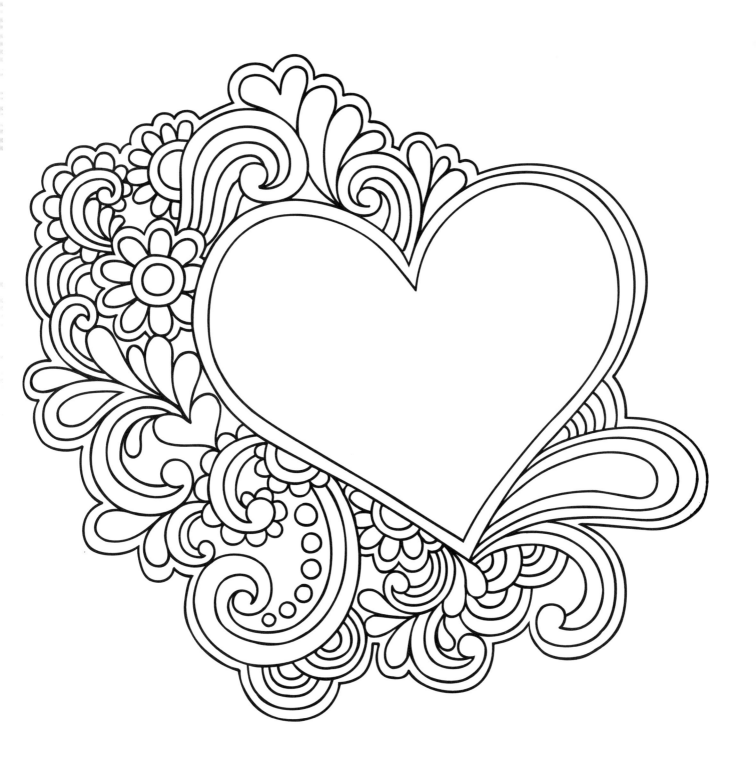

Fill the heart with your own fabulous doodley pattern!

We live in a rainbow
of chaos.

—Paul Cezanne